TEXAS RANGELAND

TEXAS

PHOTOGRAPHS BY
Burton Pritzker

TEXT BY
Renée Walker Pritzker

FOREWORD BY
Roy Flukinger

RANGELAND

UNIVERSITY OF TEXAS PRESS, AUSTIN

Publication of this book was aided by the generous support of
the University of Texas Press Advisory Council.

Designed by Henk van Assen

Requests for permission to reproduce material from this work should be sent to
Permissions, University of Texas Press, Box 7819, Austin, TX 78713-7819.

∞ The paper used in this book meets the minimum requirements of ANSI / NISO Z39.48-1992 (R1997)
(Permanence of Paper).

Library of Congress Cataloging-in-Publication Data
Pritzker, Burton, 1941–
 Texas rangeland / photographs by Burton Pritzker ; text by Renée Walker Pritzker.
 p. cm.
 ISBN 0-292-76595-9 —
 1. Photography of livestock. 2. Texas—Pictorial works. 3. Texas longhorn cattle—Pictorial works.
 I. Pritzker, Renée Walker. II. Title.

 TR729.L5 P75 2002
 779′.96362′009764 — dc21 2002002070

This is for that which walks in animals.

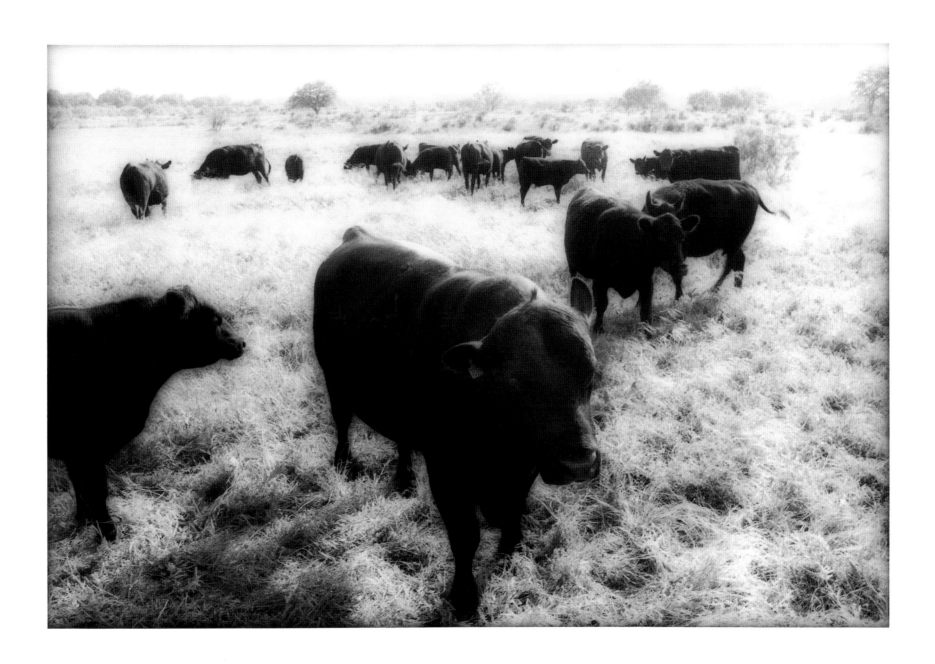

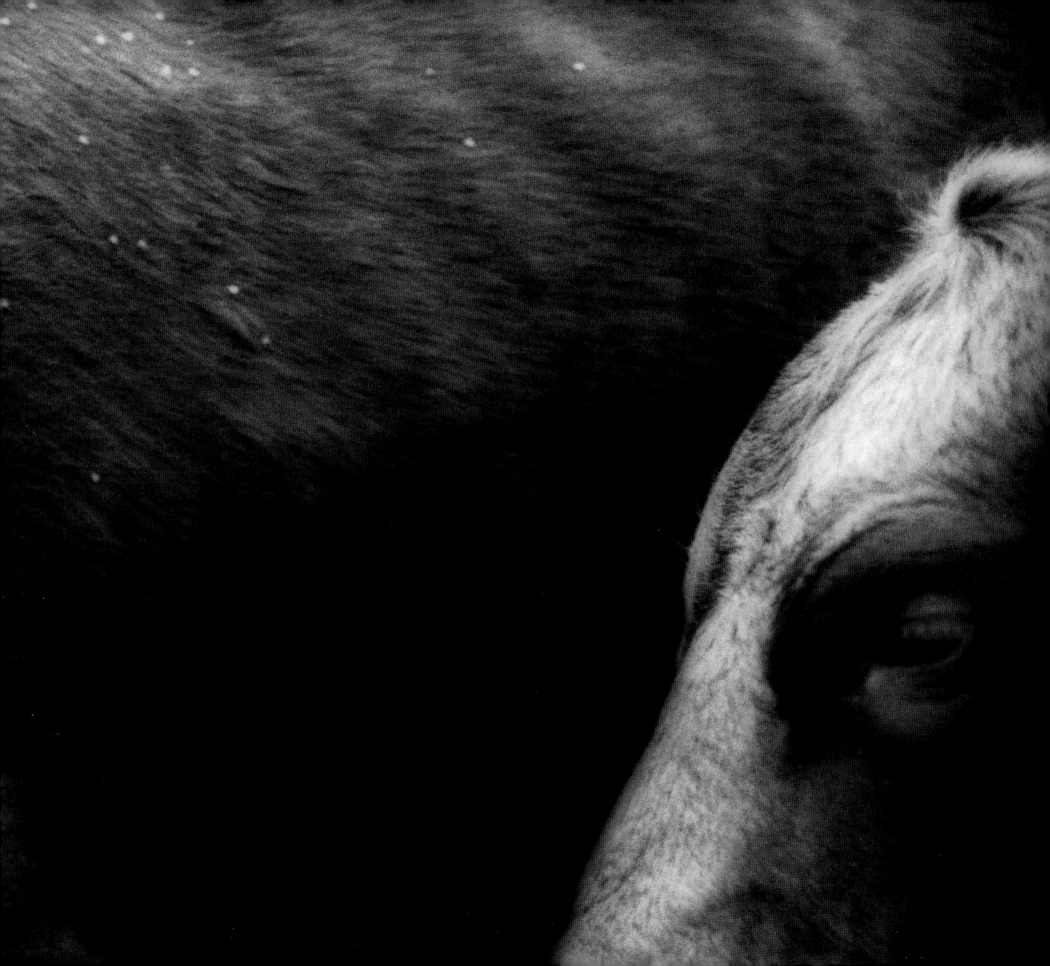

FOREWORD

It is well to find your employment and amusement in simple and homely things. These wear best and yield most. I think I would rather watch the motions of these cows in their pasture for a day... than wander to Europe or Asia and watch other motions there; for it is only ourselves that we report in either case, and perchance we shall report a more restless and worthless self in the latter case than in the first. —HENRY DAVID THOREAU, *JOURNAL* (5 OCTOBER 1856)

Perhaps an hour later, raining much harder, I passed a field where a harness-patched plow horse, white as Moby Dick, stood luminous in a piece of over-grazed pasture, his heavy head bowed. I should have stopped to photograph it. That I did not is why I have forever borne it so vividly in mind. —WRIGHT MORRIS, *WORDS AND PICTURES*

Don't play what's there; play what's not there. —MILES DAVIS

WHEN WE THINK IN TERMS OF LANDSCAPE, most of us routine-bound, urban dwellers tend toward the dramatic and the grandiose. The vast majority of us do not reside near a forest-shrouded river or in the shadow of a mountain range. There are not that many wild and magnificent vistas out there for most of us. Plus we are entrapped by the historical and cultural imperatives of this nation which led our forefathers to erect towns and cities where society and economy dictated, not where the best views were to be had. So it is not so very surprising that whenever we can break away from the deserts of our desktops and the canyons of our inner cities, our impulse is to head for mountains, forests, and oceans. What chance does a mere patch of grassland stand when compared to a place where a human being can be dwarfed by trees or rocks standing massively against the sky?

Then there is also the photography of landscape, in which we customarily find ourselves thinking in these same terms. Early photography of the American West usually featured the eloquent mountain and woodland vistas of such pioneers as Carleton Watkins, Timothy O'Sullivan, and William Henry Jackson. At the present time the world's best-known photographer is still Ansel Adams. The honor is well deserved, of course, for Adams—along with his contemporaries and forebears—did more than record the beauty of the land; he also elevated our understanding of the transcendancy of light in photography. An Adams vista has such emotional power that most students of the art, at some point in their evolution, want to "make photographs" like his. That most grow through and beyond this stage is a very good thing and something which Adams himself always encouraged.

What is most important here, however, is the consideration that there are many more paths in the landscape besides those through the forests and mountains. It is an obvious point, perhaps, but one that bears frequent attention. One of the first to point this out was that most American of our poets, Walt Whitman, who noted in 1879, during the height of the nation's westward expansion:

As to scenery (giving my own thought and feeling), while I know the standard claim is that Yosemite, Niagara Falls, the Upper Yellowstone, and the like afford the greatest natural shows, I am not so sure but the prairies and plains, while less stunning at first sight, last longer, fill the esthetic sense fuller, precede all the rest, and make North America's characteristic landscape. Even [the prairie's] simple statistics are sublime.

Burt Pritzker found his particular pathways through this American landscape while growing up in southern California. He traversed the sparse rangelands and deserts of Mojave and Nevada, trading the shade and greenery of other parts of the West for the heat, starkness, and glaringly bright light of these flatter lands. And, in the process, he found a geography and a climate that redefined beauty in terms of the introspective, the solitary, and the unadorned. Maybe Burt—whose background is in architecture—was responding to Frank Lloyd Wright's dictum "that a little height on the prairie was enough to look like much more." Or maybe he recognized in this landscape what Wright Morris's lens had found in the plains of Nebraska: "a scenic prop that was free of obstruction, where the sun was sufficient to delineate the object." Or, as Andrew Wyeth expressed with words as well as with brushes and oils, "the commonplace is the thing, but it's hard to find."

The deserts and the prairielands can do that: strip everything away and leave you alone with form and space and light, forcing you to focus upon the relative minutiae of details, texture, scale, and shape. When you are reduced to observing such sparseness, you may find that even slight changes in light or wind or point of view can stir your emotions as they make every visible form that much more dramatic or intense.

When Burt came to Texas he found ample rangeland stretched out before him. It is, as the *Texas Almanac* points out, "more than 100 million acres … devoted to providing grazing for domestic and wild animals. This is the largest single use of land in the state." Burt's internal magnet drew him through central and west Texas and his curious mind and open eyes did the rest. About five years ago Burt found his subject.

No, that is not quite correct. Truly, it found him.

While driving along an isolated stretch of state asphalt between Marathon and Marfa he found the recurring lines of telephone poles and barbed wire fence suddenly interrupted by a Brahma bull standing near the roadside. At first Burt passed him by, but—with a twinge

of intuition and electricity that many landscapists know only too well—he soon turned around and returned to the bull. The animal's position was unchanged—which is another way of saying that his natural form held its cosmic balance within the natural setting to present a kind of hypernatural or mystical subject to the returning photographer. However inexplicably, the bull provided affirmation (as suggested by the old Minor White axiom, "Be still with yourself / Until the object of your attention / Affirms your presence"), first staying but eventually moving on, as Burt hoped he might. The resulting images, reproduced herein, marked the start of a deeply felt odyssey for the photographer.

Any honest attempt on the part of human beings to connect with other animals is a profound and necessary experience. Maybe it just seems more natural to relate to another entity with eyes and a heart rather than to a pile of rocks. Maybe it is an important reminder that there are other living beings with which we as a species must share a planet. Or perhaps, as Brave Buffalo of the Teton Sioux noted decades ago, it is an intimately shared destiny: "Let a man decide upon his favorite animal and make a study of it, learning its innocent ways. Let him learn to understand its sounds and motions. The animals want to communicate with man, but Wakan-tanka does not intend they shall do so directly—man must do the greater part in securing an understanding."

Nor can one feel that a bovine source of higher inspiration is a very odd thing. I have always been particularly touched by the fact that it was a Brahma bull that kicked this whole thing off for Burt. The Brahma has a long and distinctive history on the Texas range, dating from the nineteenth century when the breed, noted for its hardiness, was first shipped here from India and impressed ranchers with its ability to withstand Texas fever. Consider for just a moment the sacredness of the cow in its original Asian homeland. Perhaps it is not so great a leap to think that this descendant of those early Texas bovine immigrants may have embodied the correct balance of religious or metaphysical spirit to have influenced an artist such as Burt.

That Burt's images are derived from this dominant animal species of the Texas rangeland is, of course, very obvious. That his choice of subject matter is as natural and fundamental as the mountains or the ocean is perhaps less obvious. And what is even more interesting is that Burt has learned a lesson from such world-class artists as Eugene Atget and Wynn Bullock: that the finest photograph, like all meaningful art, must transcend its subject and address the human qualities that lie within us all. If, upon completing your passage through this book, you believe that this work is solely about cattle, then you must go back and start seeing instead of just looking.

It is also significant that Burt's territory is a place that is shaped by people. True, they may stand slightly outside of his frame, their presence only hinted at by such evidence as the odd post or strand of wire. But the cattle are "domesticated" animals, more present than

humans within the photographs themselves, but obviously no more a part of this place than the ranchers or farmers who own, occupy, tear down, build up, and transform the land which the cattle occupy. While you look at these photographs, do not be afraid to listen as well. They speak what J. Frank Dobie called the "language that … cowboys use … as natural and honest as the exposition; it is often picturesque too, as all language of the soil is."

Today, Burt continues his journeys across the landscape, securing imagery of other animals and plants which exist upon, and help to shape the look and spirit of, Texas's rangelands. The resulting photographs, like those of the cattle in this volume, should continue to arrest our vision and challenge our conventions. In their artistry, Burt Pritzker's photographs convey an almost talismanic light which reminds us of the truth which exists in the old Hindi apothegm: "God sleeps in minerals, awakens in plants, walks in animals, and thinks in humankind."

ROY FLUKINGER

Senior Curator of Photography and Film
Harry Ransom Humanities Research Center
The University of Texas at Austin

PREFACE

THE WAY PEOPLE SPEAK has always caught my ear. Maybe because I grew up around my grandmother and her eight siblings. She was a teenager when the family migrated in 1912 from Big Spring, Texas, to California. They never spoke of Texas. They just spoke in a way that sounded like poetry to me. When I moved to Texas several years ago, I sure was surprised to hear that everyone sounded just like my family.

Bill Bishel, our editor, asked me to take these photographs around and show them to a variety of people and get their responses. He encouraged me to "cast a wide net." Some of those I met with had college degrees, while others had never left the land.

I proceeded like a water witcher with a V-shaped willow stick, moving carefully out into each person's heart until I felt the tug, the pull, that told me I'd found the source. I got more than just responses: stories began to flow. And the more people I talked with, the more that source became one voice—much the same way several springs lead down to one river. To that, I added my own voice.

This is not hick. This is pure dialect that has retained its freedom from an undifferentiated homogeneous speech. There's a way of talking—steady, without commas, then perhaps a full round pause, followed by repetitions and run-on sentences, all at a pace that runs unchecked like a slow, sure spring. The voice here comes through as poetry: reflective, seasoned, timeless, and strong.

This, y'all, is Texas.

RENEE WALKER PRITZKER

ACKNOWLEDGMENTS

THIS BOOK CAME INTO BEING ONLY because of so many people to whom we are deeply grateful: Mark Smith and Katherine Brimberry, Flatbed Press and Gallery, whose response to, and support of, the work has been as monumental as the bulls; Clint Willour, Director of the Galveston Arts Center, who not only exhibited the work, but personally hauled it from Austin and back; Anne Tucker, Curator of Photographs, The Museum of Fine Arts, Houston, who selected a favorite (*Bull #6, Marfa*) for the museum's permanent collection; those individuals who have purchased the works for their private collections; Barbara McCandless, Curator of Photographs, Amon Carter Museum, who saw the very first images and offered subsequent encouragement; Arnold and Eileen Van Den Berg, who gave so much positive feedback; Bobbie McMillan, who freely shared her insights and philosophical responses; and Bobbie's husband Lee, who deserves a big thanks for providing us access to their ranch, their horses, and LeRoy the Longhorn.

A very special thanks goes to Shirley Beth Lyles and Kurt Eppler, who introduced us to their friends, relatives, and fellow ranchers. We thank those who so generously gave of their time, and those who allowed us onto their ranches and into their lives: Debbie Geistweidt, Tootsie Stengel (and her superb homemade margaritas), Marie Allen, Alex (pronounced "Ollick") Grosse, Col. Eli Grote Jordan and Mike York, Silas Brandenberger Jr. and his wife, Patsy (and her fresh lemonade), Thom Canfield, and Nancy Holt (and her love for our dogs). A big hug goes to Gerry Gamel for his in-depth analysis of the work and, especially, his humor. And thanks, Robert Brown, for your keen eye.

Without question, there would be no book at all without Bill Bishel, editor extraordinaire, who made this all happen as if by magic, and David Cavazos, Ellen McKie, Lynne Chapman, Dave Hamrick, Nancy Bryan, and all those involved with the project at UT Press.

We're very grateful to Henk van Assen—who said we should all do a book one day—for the way in which he brought this one so beautifully to fruition, as only a great designer could. He is also a great friend.

As for Roy Flukinger, his introduction is truly a gift, and brings to this book a stature that reflects the bigness of who he is. "Thank you" doesn't even come close.

BURTON PRITZKER & RENEE WALKER PRITZKER

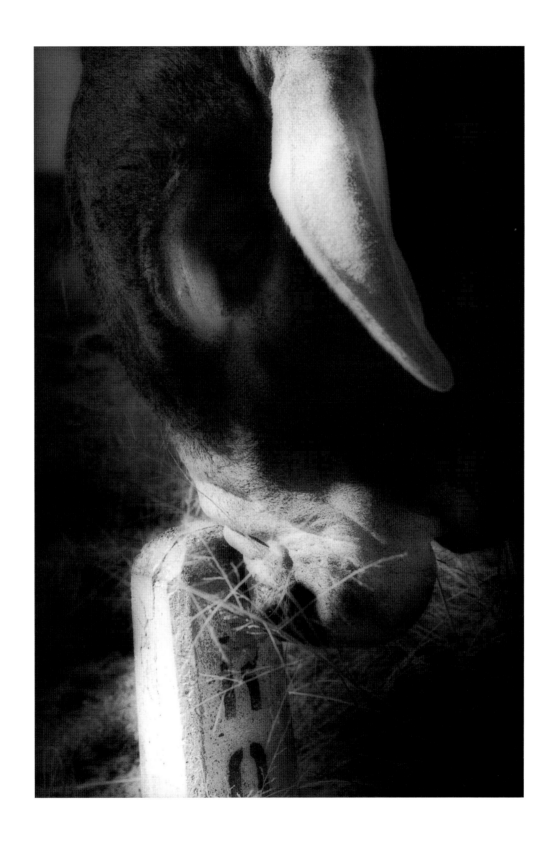

These forms in a way are architectonic. They're like big structures. He takes an organic form and he converts it into

architecture. I like that a lot. At that level, it becomes a kind of monument to Bullness, a monument to Cattleness.

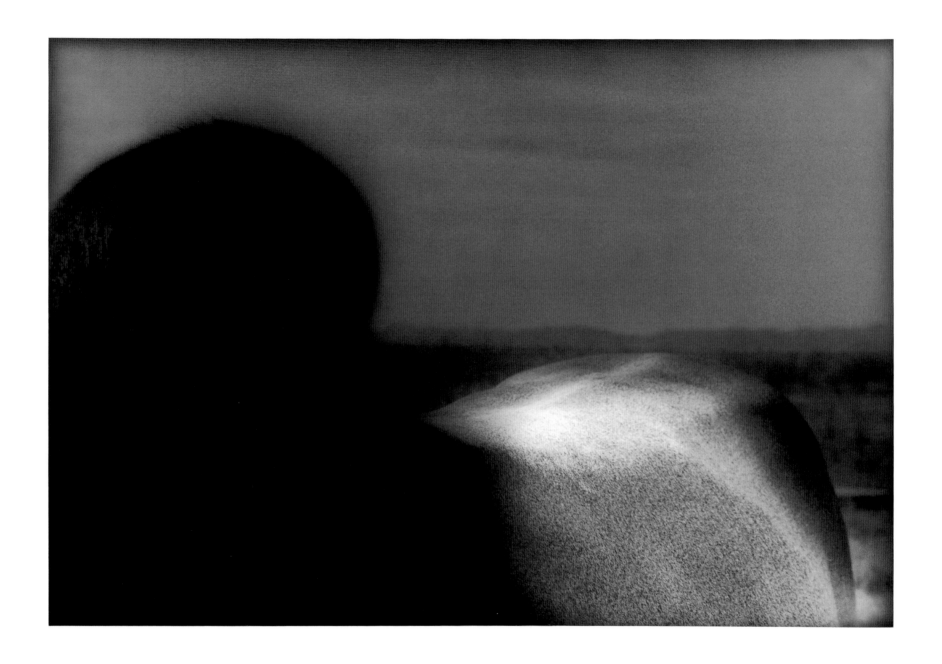

Yep. Here in Texas we've got cattle from Llano to Mason to Blue Mountain, from Hext clear out to Menard and east of Eden, from Spur to Matador to Turkey, down there between Marathon and Marfa, and even out on Galveston Island. Just about anywhere in Texas that ya go, you'll see cattle roaming. Or they might be layin' down in the high grass or underneath post oaks, dependin' on where you are. Oh, they'll make their way among the prickly pear just fine, you bet. And if they want water, they'll climb over them granite out-croppings if they have to—to get to the tank—or the creek, if ya got one.

You see all that granite by the road? That's our ranch. I love walkin' over those rocks. Especially at night when there's a moon out. I've been walkin' over those rocks since I was a kid. And every time I still see somethin' new I never seen before. When it rains, they sure look different. And in the summer, those rocks are hot. They're really hot. I love 'em.

I tell you what. You can see a bull just standin' alone, he'll just stand there all alone, nothin' around for miles. And if two bulls are together, you just might hear them bellowing at each other. Oh, it's a sight. I never get tired of seein' em. Cows or bulls. Dudn't matter. I never get tired of seein' either one of 'em.

[BULLS & COWS #12, MASON, p.3]

When I first saw these photographs I was really struck by them. Not because they were cows so much but because of the shape of them and the formal nature of them, first. I love the formal quality. But then—knowing they were steers and bulls, bulls especially—that made me think about how I grew up.

We had a farm and we had cattle on the farm. Not like a large ranch but enough that we could have fresh beef that we'd put up about every other year. And we would sell some cows and use it to buy feed. The fallow land is where we would graze them. So I know the nature of bulls and cows.

So when I first saw those photographs I was so struck by how's anybody getting this vantage point. Because cattle are skittish usually, unless they're tame, and you don't usually have that point of view of right up close. And I asked Burt if he'd used a telephoto lens and he said, "No, I walked right up to them." And I thought he has to be some sort of magician to do that because he was able to capture something that very few people, really, ever see—you know, to get a sense of the whole shape of a cow but be up that close.

I mean, this shape, through the fence, I love this formally because the way it sets up. Sky, cow, fence, and the fence as the barrier. But that's probably more like the whole shape you usually see of the cow. I don't know how he does it—but they are more magical than when you see them just drivin' by in a car.

We farmed and ranched near Lubbock, Texas—the High Plains. These look like Sharlay [Charolais] cattle which is what my dad had. Fences always seemed kind of inconsequential compared to the cattle. My dad went and got a whole hundred head of Brahma from Mexico once to mix with his Sharlay and brought 'em to our ranch farm. And he had set up

[COWS #1, HIGH PLAINS, p.39]

23

an electric fence around a kind of corral and he unloaded them and they took off. Just broke down the fence. They had no concept of it. When you think about it, that's not much of a fence for that kind of animal.

[BULL #1, HIGH PLAINS, p. 72] Oh my, that looks part buffalo. Yeah, that's a really nice old fence too. That looks aroun d'Amarillo. I've never seen that kind of cow. I'm always so curious about why he liked looking at bulls. I mean, they sure are wonderful to look at and not very many people pay attention.

[BULL #10, MASON, p. 97] Oh, what a majestic animal. See, I don't understand how he was able to walk right up to these bulls. Cuz bulls ordinarily will come at you. I stumbled into a pasture with a bull one time and got chased out. They are not very friendly. I did raise steers but, you know, if you raise them from real small calves, they like you. And of course, steers are different than bulls. They have had a little bit of "alteration" and they tend to be a little less aggressive.

This is how our bulls usually were—by themselves, in the field, isolated, until later when bulls were practic'ly of no use anymore. You know, people go buy semen. You don't have to have a bull. It's expensive to do that if you go to get champion semen. [BULL #24, MASON, p. 44]

The mamas really are good with their babies. They take care of each other's babies, you know—even though every calf knows its mother. And every once in awhile we'd get an orphaned calf and one of the other ones would adopt it, and then it would have nourishment. During the day, whenever we'd go out to see our little herd, there'd always be a pocket of the babies over in one corner and one mama kinda watching over the babies while the other ones went around eating. And if they felt threatened everybody ran back over to the babies. It's kind of fun to see how the herd works. The herd really is kind of a real complicated thing to watch how they interact and all. [COW & CALF #17, MASON, p. 111]

Oooh. That mouth! When we used to raise for 4-H there was a real love-hate relationship with the calves cuz they were kinda stupid. Those steers were. They were just clumsy and they'd step all over you and they'd be stubborn but then you'd love 'em because they'd be gentle sometimes and soft. Although their mouths sometimes were not real clean, you know, real slobbery and all and, teenage girls like I was then didn't want to deal with stuff like that but you end up learning how to anyway. [STEER #14, ART, p. 98]

I remember being so sad about taking my calf whenever I'd go to the final showing, cuz they'd take 'em away to be slaughtered was what they did. And I would be so sad about it. And we'd been washing and combing our calves—currying them, they call it—and we'd take their tails and wrap them up. I don't know why judges liked this but they did. You would do all these things to make your calf beautiful. And then you'd go in there and they'd get judged, and then they'd cart them off somewhere. And I'd be sad about it until, I think the last time I did it, my calf—I've forgotten his name now—anyway, he stepped all over my feet and broke my toe. So I wasn't too sorry to see him go. Maybe that's why that happened. So I wouldn't have to feel guilty.

[STEER #3, CASTELL, p.83] They are remarkably like—you know, the look in their eyes—they just seem very human or very feeling. You know, that's why you can get pretty attached to 'em when you raise 'em.

That's such a different perspective. Well, that's sort of how a cow gets to know you is with the mouth. That's sort of their sensory organ. It's very moist and slobbery and slimy. It doesn't look quite like this. This is really beautiful. And that's how they'll nuzzle your hand or your face or anything that's close by. I really do like that, the way it's abstracted. That's one of the things I do love about these photographs is how he tends to find the extra ordinary in something that somebody might find very ordinary. Like that nose. [STEER #4, CASTELL, p.119]

That's really gorgeous with the ribs. And look how his black tones glow. It's almost a reverse kind of light, isn't it? The areas of black have such a great richness to them. And the black almost seems to radiate as light instead of the white. I think the little tiny bits of gray beside the black, perhaps, with the silver, makes those blacks so radiant. And it's such a big beast. It's a wonderful beast. [BULL #3, ROUND MOUNTAIN, p.77]

Here's those glowing blacks again. It's a kind of radiation of black coming out from these areas of mass. You know it really gives the creature some sort of eminence. To take something so large and to make it into something a little bit different and so abstracted. [BULL #4, MARFA, p.121]

They all have a human quality to them but this one seems to be such a man. Half a ton of bone and meat and muscle. [STEER #9, MASON, p.35]

Look how the light just falls over the form. That is so wonderful how it's all described by the light. I can't help thinking when I'm looking at these about—you know, I eat meat and, you know, about beef, cuz when we showed cattle, well, we'd have those judges—they would all look at bodies like that and that's all they would see is—this cut is here, and this cut is there—and you look at a body like that and you oughta be able to see more. It really just seems more like a wonderful big organism body and you try not to think about all that other stuff. [BULL #8, MARFA, p.22]

[STEER #7, ART, p.40] I think I like this one formally a lot but not as much as I like the ones where they have the eye contact or even the body. Formally, I mean the way the horn is slightly out of focus back here and then there's another layer of space and just how the space gets divided up formally. And some of the space is not real clear but it's got a wonderful sense of black and dark. I like that. I like the way I move back into space. Kind of like a collage.

[BULL & COWS #19, MASON, p.53] But this I really favor, myself, when he captures that monumental part whether it's the back of the bull here or the head. I don't know if I were a cow if I'd want to be branded or have my ears pierced. Branding is pretty bad too, if you've ever been to a branding.
Well, it is always pretty amazing when you see a big bull or steer and you think about their legs and their bodies are half-ton bodies or three-hundred, four-hundred, five-hundred-pound bodies and they are all on these little spindly legs. When we were showing cows, what we'd do is we had a little stick with a little nail at the end of it, and when you put the

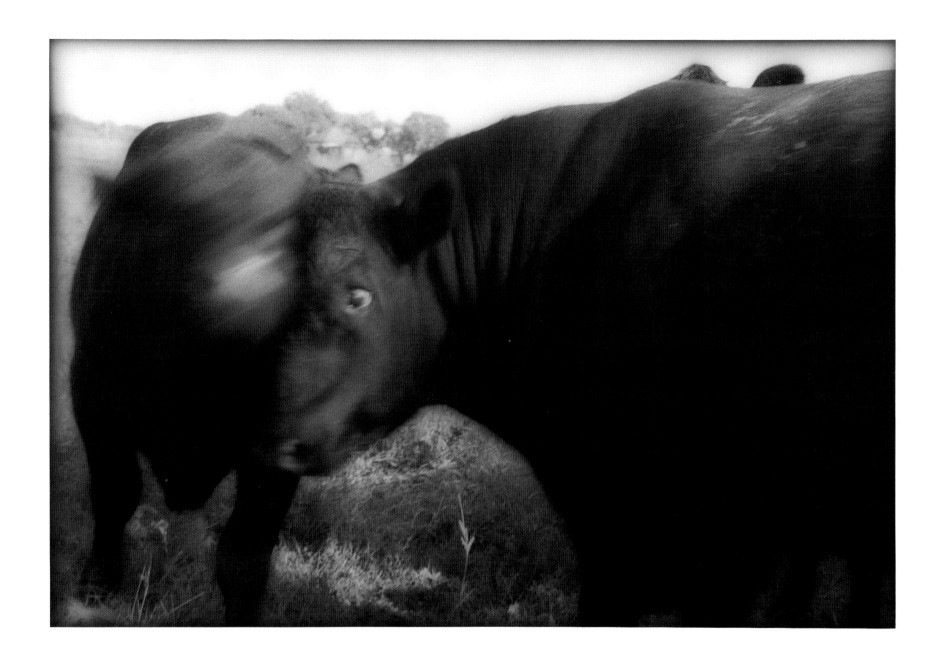

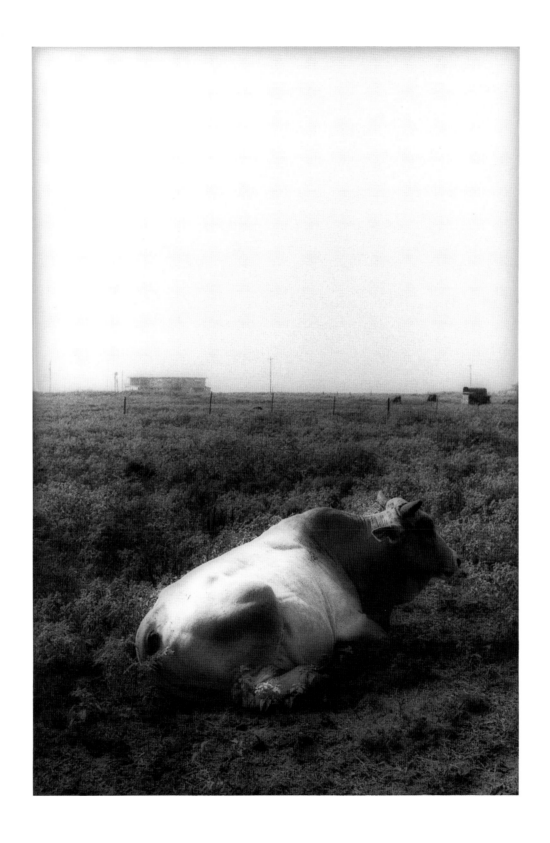

steer in front of the judge you had to make their legs line up like a box. I don't know why. It shows off their muscle better, for some reason.

Well, if you just barely tickle right there in the foot with that stick you could move the hoof where you wanted it to be. They're very sensitive there. You just pick the foot up and move it where you want to and I guess they shift their weight on the other three legs while you guide them. And it's a five-hundred-pound steer that you're standing beside, moving their leg.

[BULLS #2, LLANO, p. 134] Well, that's a little more than five hundred pounds. They look like they're made out of bronze. They don't look like they're flesh and blood. They just look so—whew—so timeless and bronze-like. They're very masculine. You know those sculptures of the wrestlers, those Greco-Roman wrestlers? They really remind me of those.

I don't know if you've ever heard this story but it was always a story my dad told me about, because they always had beef growing up, they always had their steers growing up, and back in the twenties and the thirties there were no workout machines. So the young boys who built their muscles, other than just plain work, would lift animals. They were encouraged to.

And my dad always told the story, "Well, when a calf is born, if you go out every day and you lift it, lift it several times, I don't mean just lift it once, and every day you do that, by the time he's a steer, you'll be able to lift a steer. Or by the time he's a bull."

Think about it. When's the time that you wouldn't be able to? Would you ever be able to lift a bull? Course, you probably couldn't but that was the story he always told us. If we would go out, if we wanted to be strong, and go out. But I didn't. I was a girl and I was more interested in other things.

There was supposed to be a notoriously very strong man in Cisco, or Scranton area up around Abilene, and that's how he got strong. You go out when one is just born and you lift it every day. Every day. And eventually you're able to lift a bull. And that man was able to lift a bull.

[STEER #2, BIG SPRING, p. 55] If you're with any of these cows, they have a funny kick. They kick sideways. Horses kick straight back. Cows are very flexible and if you walk alongside of 'em, I mean, I was always gettin' kicked. Because if you walk too close and too fast it kinda takes 'em by surprise right there, and they'll go *kkhh* and they'll gitcha. Their bodies are amazingly sensitive. About their legs too. Just watch 'em trying to get off flies.

I love how he puts the barbed wire on top of them. Soft round forms with a hard grid. And [COWS #1, HIGH PLAINS, p. 39] softer forms above, that are not solid. Softer, solid, gaseous. You know, it's funny. The herd does do things like that. They'll just sort of point, and just go together. There's a herd mentality. They'll all start going one direction at a certain time. Or if there's a storm coming, they'll all lay down. It could be real nice and you see the cows laying down and it's like, "What's happening, is there a storm coming?" Some people say if you see them laying down on their haunches, that's a storm. But if you see them laying all the way down, that's because they're sick. They're dead or sick.

Cattle have come and gone. Just like the people. Ranching has been good, not so good, and darn near impossible with the drought and all. Ya know, it doesn't do any good to complain. That don't make it rain. Some folks are rentin' out their ranches for riding horses or to them people who look at birds. Things like that. Anything to keep hold of the land. Some of it's been in the family for generations. The hunters sure help. Weren't for them, this town'd dry up. I've lived here all my life and everbody's had their share of bad luck one time or other. But I don't know a soul who's complained. Think of those poor people way back when. Trying to ranch and raise a family too. Nearly did in a lot of folks. Just go out to the old cemetery and you'll see what I mean. Tiny little headstones all in a row.

ALEX DONOP	HILDA DONOP	ARCHIE DONOP
1897–1901	1900–1901	1917–1917

No. Nobody complains. Everbody just picks up and goes on. That's just the way it is. But I like these here photographs. Yeah, they make ya look twice.

That's what Billy's been trying to get Roy to run with his white cows is Sharlay [Charolais] bulls. They're heavy bodied, big boned. We've been kind of reluctant to do it because their calves are so big. Ours are tiny little black things no bigger than a cow dog. But there are lots of people who have Sharlay and they do make a beautiful calf.
Roy said if they have to destroy all those animals in Europe with the hoof and mouth disease it just makes ours more valuable. Isn't that awful? They're gonna ban the export of all that meat. And so is Canada. So now they'll have to eat ours.
With all this green grass, though, it's so beautiful out there now. We used to when we drove into a place to feed we didn't have to call them much. Just honk a horn or something and they'd be all over him. Yesterday we spent twenty to thirty minutes. Boy, did Roy get mad. I took off. I go walk. See what's going on. Take the dogs with me. And he stands there and just calls and calls. He has this little musical horn that's a megaphone and it has a number of all these songs. He can play *Battle Hymn of the Republic* and *The Wedding March*. There's numbers on it too and the numbers each have a tone. So he'll just push like 8 and 9. Kinda sounds like the horn on his pickup. And he calls them that way. And then he plays songs for them when they come. And when he's all done he calls me. AAAAooooooo! AAAAooooooo! It's so funny. But he was just wearing that horn out yesterday. I kept hearin' it and I kept lookin' at my watch and it had been thirty minutes and he hadn't

called me yet. They just wouldn't come in. They've got all that grass is why. You know, Roy calls them Democrats. During the dead of winter when we're having to feed them so much we'll come up to a place, and they'll just be plastered up against the fence. He says, "Look at 'em. Democrats waiting for a handout." He's terrible!

Yesterday morning I got up at zero-dark-thirty just to listen to the rain giving us all that [CALF #1, STREETER, p. 81] green grass. So many of 'em have their little calves with 'em now. They're so precious. So vulnerable and so soft. He's got between twenty and thirty mother cows at a place. He's got 'em in manageable numbers. But when it's in the forties, that scares me. That is a lot of cows. When you're out there feeding them and he takes off with a sack of feed, that's the only place I help him pull cuz he'll start running with a fifty-pound sack of feed. And I'll rip open another one. It takes me forever to lift it up. I don't run. I sprinkle. But that way they don't all follow him. That's the one place I don't really feel safe. We could feed 'em from the back of the pickup but we're too macho. We'll do that when we get old. I've already brought that up.

But we had one experience with that which may be why Roy doesn't want to do it. He got in the back of the pickup one day with a calf. The calf got separated from the mom in the field. So we went around and he picked up the calf and sat on the tailgate of the pickup and said, "Drive on around to where the mama is." And I said, "Okay." So I started driving along and I went through the gate and up and down and never looked around and he'd just popped off! And I'm just driving along and finally look back and—no Roy! He was way back there on the ground still holding that calf!

But I sure do love watching him with the animals. You can tell he was born and raised out here. You can just see it the way he walks around a big old bull, just touching him. I wouldn't get that close to it. It's amazing they stay inside a fence. Just think—a barbed wire fence keeping such a huge animal in. They know they better not get up against that fence cuz it hurts. Sometimes they knock 'em down. If there's a heifer on the other side. Or something interesting over there.

[BULLS #2, LLANO, p. 134] Look at these guys. Oh, they're gorgeous. Our bulls are very similar to that. I like that though. Side by side. See all that muscular. They're really powerful animals. I like the roar bulls make. Those guys are running in the same pasture together. They might could be related, you know, or raised together. I don't think people understand how if you have a pasture full of cattle, that is a community. It's a small city out there. You introduce a new person. They get shunned and all that. These guys like each other.

[BULL #9, BIG SPRING, p. 90] That's the shoulder. That's the hip back there. That's the hip bone. That's the pose we all want to see them in, see. Head down. Means she's eating. Looks kind of like a rock. They do look like rocks, though, if they're in a field of deep grass and you're far away. Our cattle will look like big black rocks out in the field cuz they're not moving. That's kinda nice too when they've had so much to eat that they can stay in one spot. It's so interesting to see things that we everyday deal with to see them photographed like this. I like that.

[STEER #7, ART, p. 40] Those Longhorn spots are great. Did you read *Lonesome Dove*? A Longhorn's horns, I didn't realize this, but when they were doing the cattle drives the horns would conduct electricity. Lightning. A ball of lightning. The shape of it just reminded me of that.

[BULL #1, BIG SPRING, p. 89] I love windmills. That's what makes that picture special to me. We're so lucky to have 'em. We forget sometimes. Windmills are getting harder and harder to find. Harder and harder to find somebody to work on 'em too.
I love this one—Longhorn—feeding—isn't that neat? Now see, that is just the quintessential Texas to me is the Longhorn. They can just live on anything.

We had Napoleon for years. He was a registered Longhorn and when my son was little he loved to feed him mistletoe. That big ol' animal. If Ben would start cutting it, he'd come. You didn't have to call him up. He would come. I've got a few pictures of that little tiny boy and that big Longhorn. I love Longhorns. They're my favorite. [STEER #4, ART, p. 99]

It amazes me with his black-and-white photography that he can see these contrasting shadows through here. I'm amazed. I'm amazed that he can pick up these shadows. [BULL #6, MARFA, p. 93]

I forget how much I love black-and-white photography until I see something like this. My grandfather was an amateur photographer. It's a whole different perspective than color. Oh gosh, his brisket. I love the shadows. I love the contrast. [STEER #1, CASTELL, p. 126]

[STEER #4, CASTELL, p. 119] Oh-oh-oh. I just wanna kiss this. The mouth is so soft and it's always kinda moist. I love how cattle smell. Incredible. Incredible how he could pick up this darkness.

[BULL #1, BIG SPRING, p. 89] Longhorn. And they don't even look real. We have Sharlay [Charolais], Black Baldy, and Brangus. The Black Baldy are the black body with the white face. The Brangus are the Brahman and Angus. They're black but they have the heavy brisket in them. Not much of a bee sting on the back but you can tell they have the Brahman in them with the kinda sad-looking eyes and the larger ears that hang down. They're pretty but they're a lotta cow. I like the Black Baldies better than anything cuz they'll do better on little as nothing. They're not quite so hard to work with. You can rattle a feed bucket and they're not gonna run over the top of you. The Brahma—they are a little feisty. They-a-little-feisty.

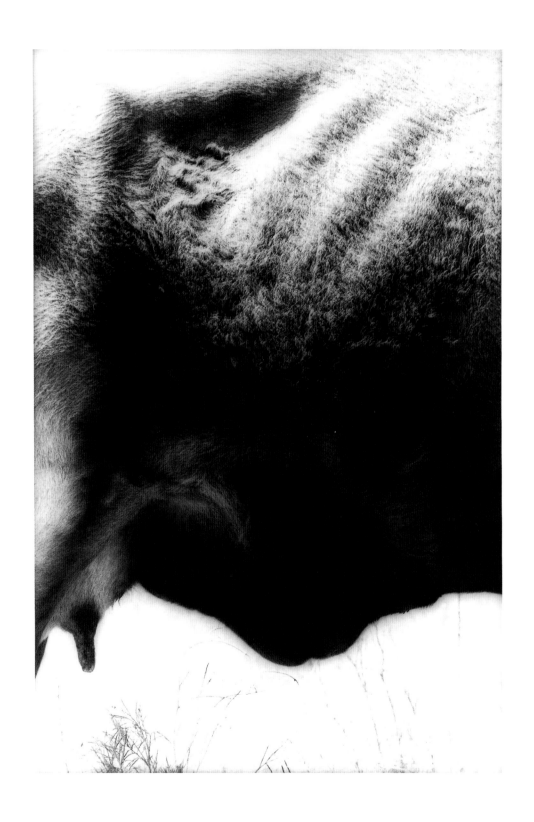

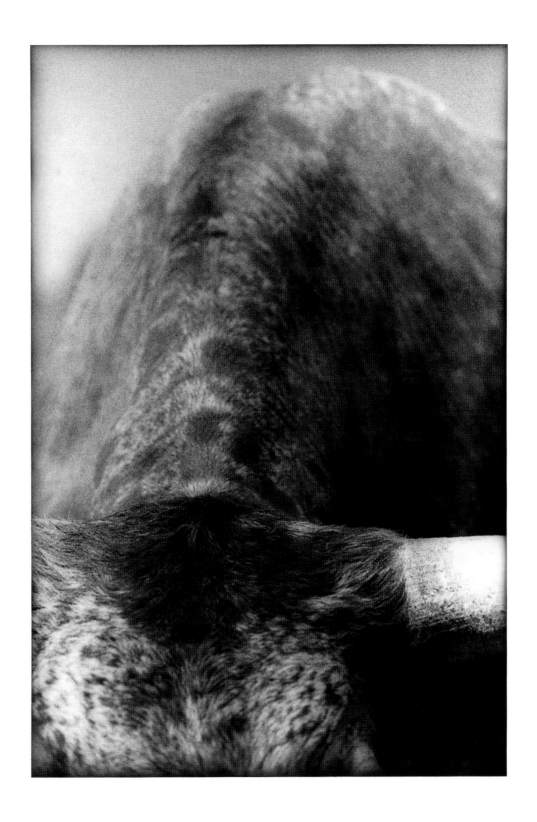

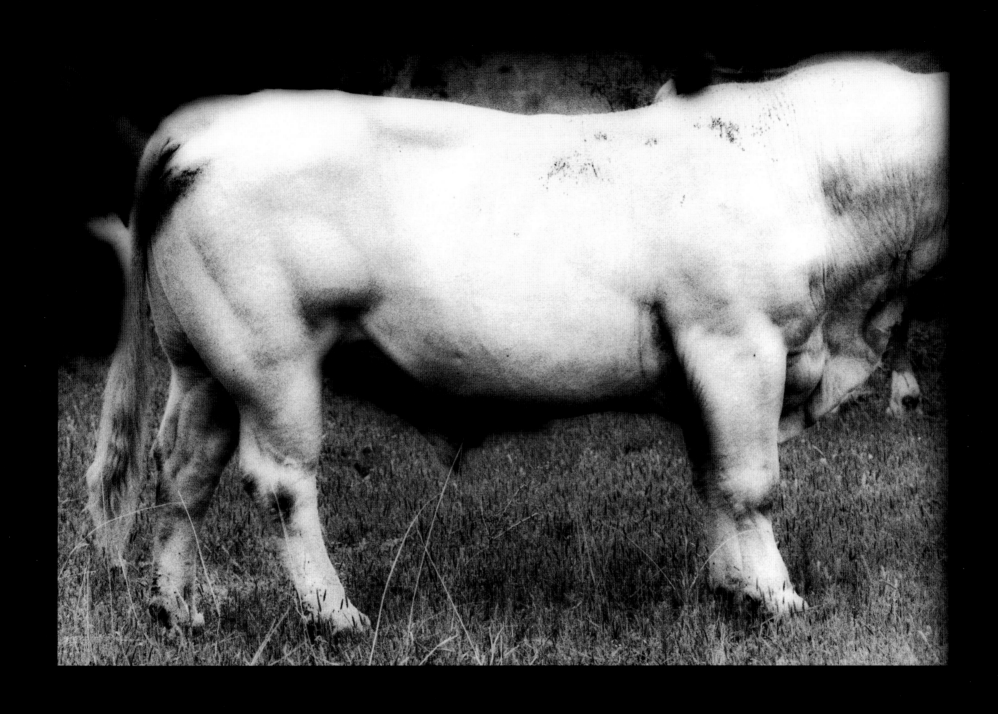

Oh, Brahma. See the bee sting. That's the hump. But he's kinda bony in the back. [BULL #3, ROUND MOUNTAIN, p. 77]
It's probably in winter. Well actually, it's in the trees. There's a few leaves. But it
was so droughty and so dry.

[COWS #1, HIGH PLAINS, p. 39] Oh, great clouds. Sharlay. I think they are. See the light color. They could be Lim-
mazine [Limousin] but I don't think so. Kinda hard to tell in black-and-white cuz
the Limmazines have a different coloration. The Sharlay are creamy but they look
a lot alike. They're English European-bred cow. But you know, what the Europeans
are goin' through right now with that hoof and mouth stuff is wild. This world is
quickly changing.

Oh-oh-oh-oh. I had one like this I raised on a bottle. She was a dogie calf. And I called [COW & CALF #18, MASON, p. 80]
her Laverne. And last summer Laverne got bit by a snake and we lost her. She was this
huge cow that would come to me and let me rub her and scratch her. Not fractious. Not
rough. She loved apples. I fed her apples. And literally, when she would be down laying
on the ground I could crawl up around her. And I cried like a baby and couldn't come to
work that day. Over a cow!
But I'd go over there to the fence and I'd call, "Laverne!" and here she'd come. And she
had that kind of face—sweet, sweet. With the little freckles on her nose. There's some-
thing about the Baldy cow. They're a cross between the Hereford and the Angus. The
Hereford bulls and the black cows. But this one he's got here is wonderful.

Itchin' and itchin'. He waited awhile for this one. To catch her like this. Yes, he did. [COW #3, MASON, p. 125]
She's really eyeballing him too because you can see the whites of her eyes. It's
almost like she's teasin' him. They can be playful. It's amazing to me how large
some of the bulls are and they just frolic like a little calf at times, especially when
it's cool. Or when they hear Buddy's diesel truck comin' up the road and they know
they're gonna get some cow cookies.

Look how fine the little hairs look around his ear. I'm very impressed. These pho- [STEER #6, ART, p. 41]
tos have made me look at these animals a little bit differently. How wonderful. I
never thought about them in the abstract. And I love the way the lines are. And it's
the reminder how wonderful black-and-white is. How much more is really there in
black-and-white.

Scratch scratch scratch. Where's her baby, her bag sure is full. I love their little tail [COW #4, MASON, p. 109] hairs how it likes to curl. It's amazing something that big can scratch its nose. She's got a big ol' bag. Where's her baby?

[BULL #5, MARFA, p. 141] I would be a little concerned about getting this close to some of these guys. But he must be very calm. So they don't smell the panic. And he moved easy. But this is a really large animal and they can be very dangerous. Look at the little moisture on his nose.

[BULL #4, MARFA, p. 121] He's one of those dark-blue gray. Dark. Beautiful. Sad eyes. The Brahmas have such sad eyes. I bet there's a lot of people who really can't identify some of this cuz they don't know. I'm just amazed at all these. And I can't thank you enough for sharing this with me. I feel very privileged.

- -

[BULL #1, MARFA, p. 131] When it comes to ranchin', my wife knows more'n I do, and she's smarter'n I am. Ask me if that's true of all women and I guess I'd have to say, as a rule, yes. Looks like a Brammer [Brahma]. Looks like that man might need to do a little repair on his fence. I started to say that musta been takin' out where they always have a drought. Well, you know, last year—it never has looked that bad—but last year it was really bad—you wouldn't recognize this place had you seen it last August—and see it now. You wouldn't believe your eyes. You couldn't see any grass out there or weeds. It was from between here and my barn just bare ground. It was that dry. And a terrible heat wave. In fact, we've been in a drought now about, oh, five years. Not real bad but it has gotten progressively worse. For several years now.

I was raised on a little ranch west of here, and those pastures had big splotches where the grass just died. And when these rains came those big splotches of ground were just dirt. And of course, now they have covered with weeds, hoping that the grass will grow. Grass doesn't grow very good until about May and June. That's the best grass-growing time of the year for our area.

That's why it's so hard for a rancher to keep grass on his place because you don't know what's ahead. Now if it stays that way, then you won't have any grass that year. So you have to look ahead. I guess that's one of the hardest things there is about ranching is that you have to try to adjust your stocking rate, how many animals you run, according to the weather conditions.

We're so dependent—a rancher is so dependent on the weather, on rainfall. It's just—well, you're always figuring. Or trying to figure ahead of time what is going to happen. And that's not so easy to do. And so many times you're wrong. You don't know anything for sure.

You really don't. I've noticed that, since I've never done anything else but ranch. I can't really describe it—how it feels when that is your only income. You better lay away for the bad years when you have a chance during the good years. I guess, on my own, I haven't been ranching really completely on my own, but about fifty years. Well, we married in '46. It will be this year in June that we've been married fifty-six years.

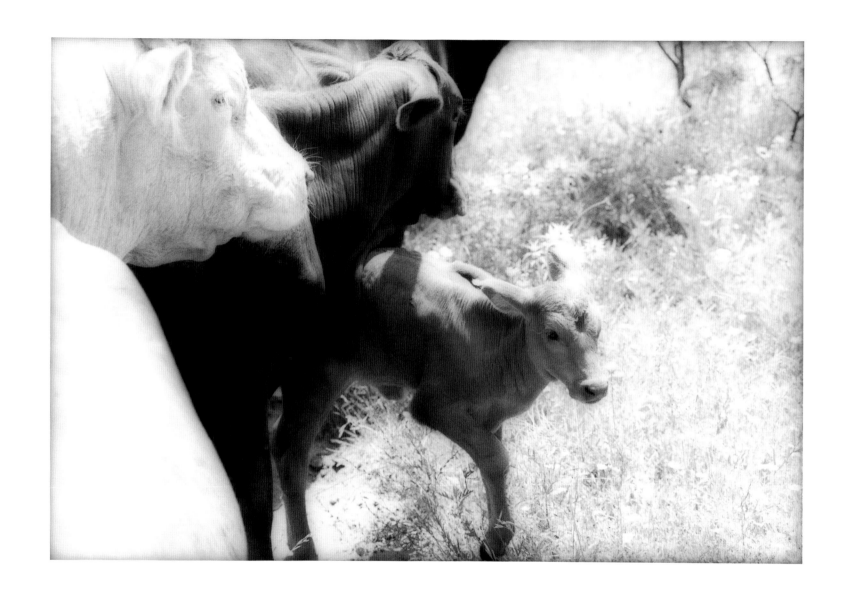

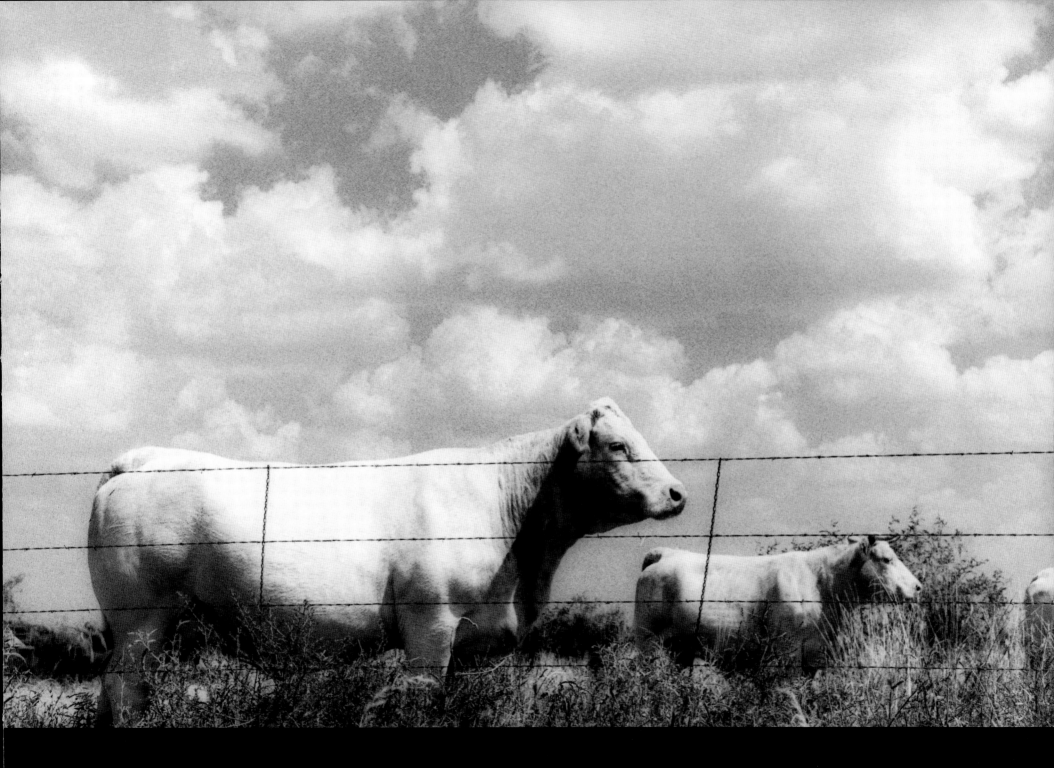

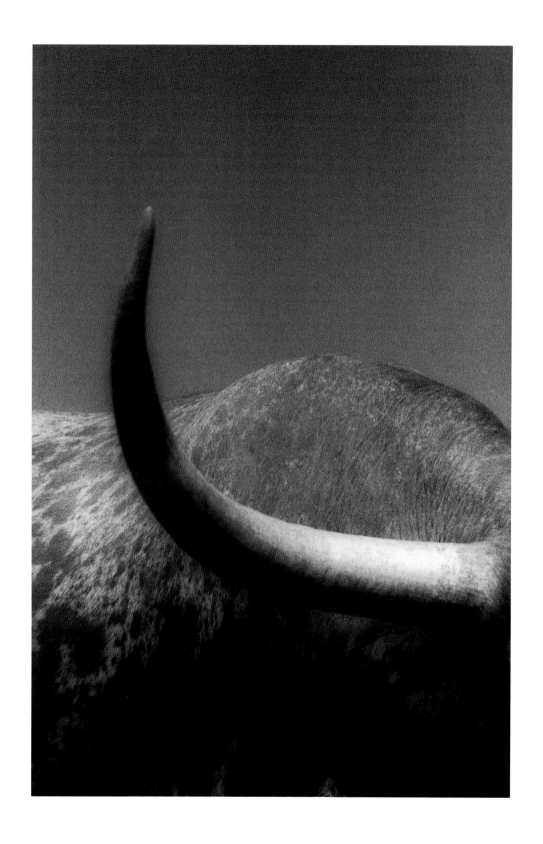

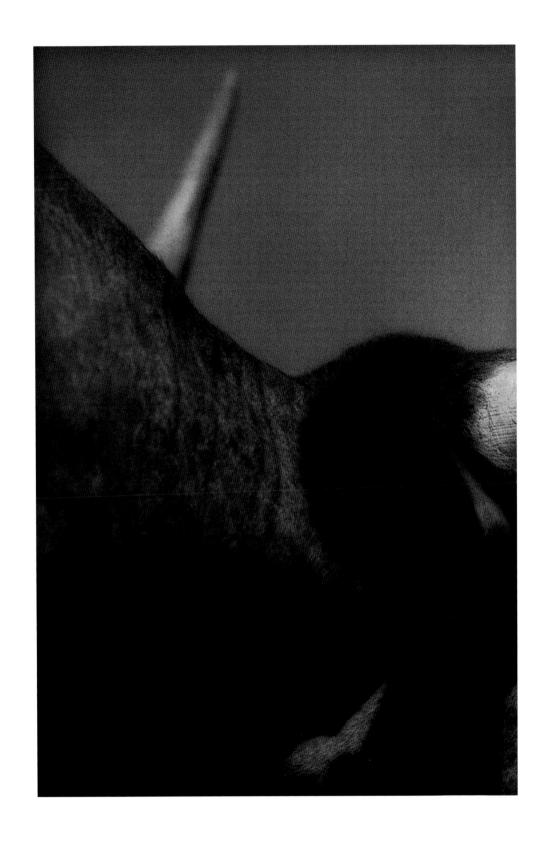

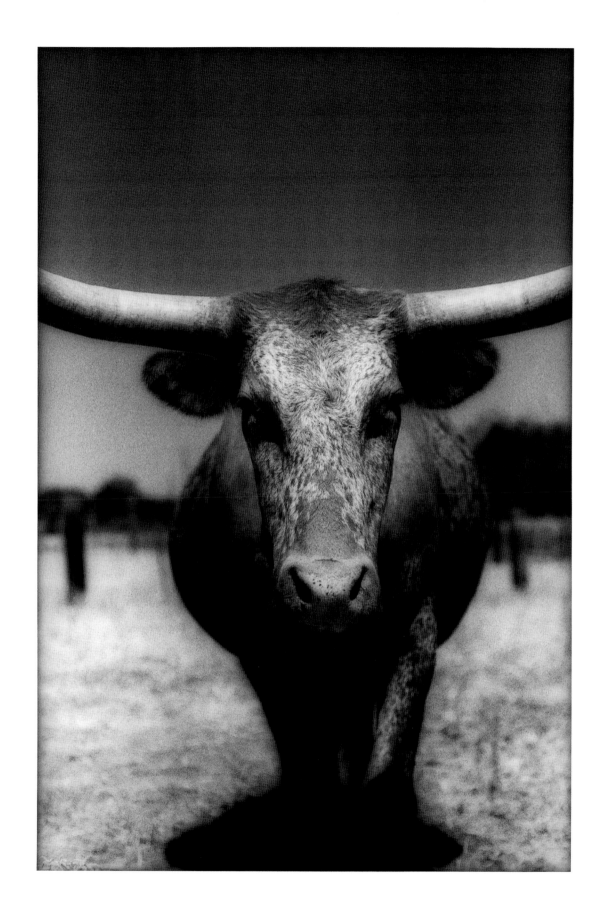

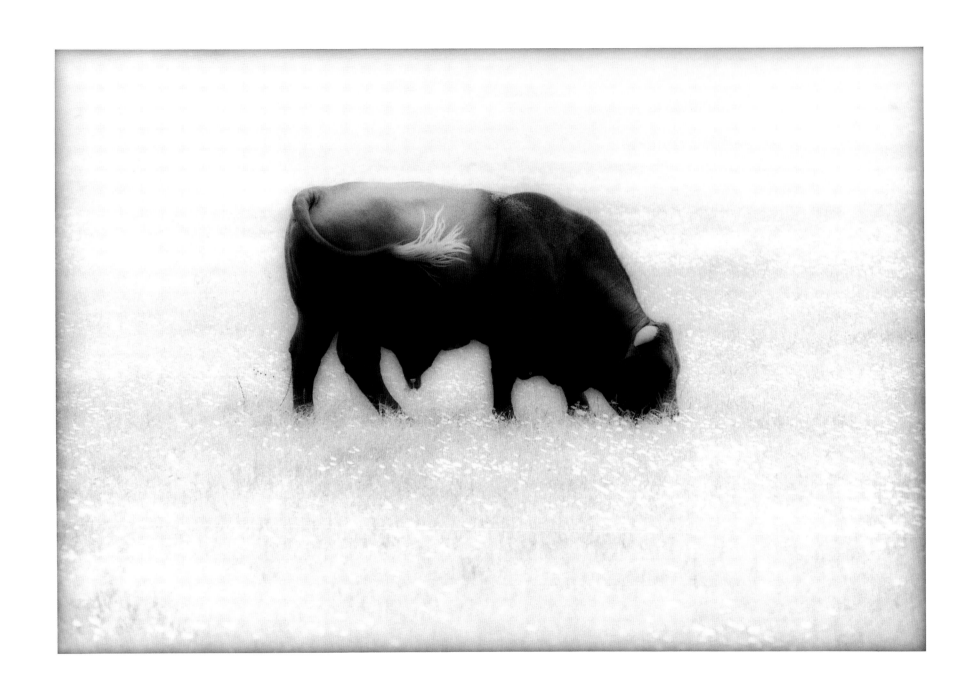

About the first four or five years after we were married, her father I ranched with him. This was his ranch. My wife's father. And I ranched with him, you know, we did it together. But actually being on my own, it hasn't been but about fifty years or maybe forty-eight, forty-nine, forty-eight years.

And in that length of time, I found out when you do have a good year you better try to save money to take care of the lean years. And then on top of that, this is the big thing, if you have a family and you want to educate your kids, that puts an extra burden on you. But we were lucky. My wife and I were lucky that we lucked out like we did. Prices were pretty good when our children were in school and high school. We had four children. And we actually had enough money that we could give 'em all a real good education.

[BULL #6, MARFA, p. 93] That's really a close-up, idn't it. You can even see the little bitty hairs on his ears there. I always kinda liked those animals from a certain standpoint. I guess what I liked about 'em was their hardiness. They're very hardy. They don't need as much forage to survive on. They may get thin, but they'll survive.

That looks like a Longhorn. May not be but that's what it looks like. Well now, those people had [BULL #1, BIG SPRING, p. 89] some grass. I noticed that first because I'm very interested in grass. You know there was a rancher west of here. He raised quarter horses and Aberdeen Angus cattle. They're black. In case you don't know about Aberdeen Angus cattle, they have the best beef of all the beef breeds. They originated in Scotland. Best beef breed and that's the only kind I've ever had.

I just worked some this morning. We branded some heifers. My wife helped me. I had some heifers I kept to keep for cows this next year. And I branded 'em. I gave 'em our brand and the year brand so I know how old they are when they get several years old. Easy to identify.

What I was gonna say about this man that had these registered Angus cattle—he had a man up one time to look at his bulls. This man and his son, in fact I heard this story from his son, he said he and his father went up there and were gonna go out and look at the bulls.

So they drove out there in the pasture about a mile or two, and all of a sudden the old rancher stopped. And he said, "Now, I want you gentlemen to look at that. That's the prettiest sight in the world. Just look out there." And the son said, "Mr. Coy, I don't know what you mean that's a beautiful sight." He said, "Well, there stands an Angus cow in tall grass and on the other side of her is an oil well."

Yes, I've always liked to have an oil well ranch but I never was that lucky. I didn't get that lucky. That'd be the easiest ranching in the world.

[STEERS #6, BLUE MOUNTAIN, p. 60] Yep, there's some more-a-them Longhorns. They've got these animals scattered around in a lotta places. It's a sight how there're more of those now than there have been. We've gone that way in so many ways in the last fifteen years. It is a sight how people have gone to exotics, so to speak. Not only in domesticated animals but wildlife as well. But that's where the money is. You know people are getting into where the money is. I don't know what they get for cattle like that but part of it is they just wanna have something different than anybody else. They just wanna have something different.

Well...this photographer don't only take pictures of animals but he tries to get a view of all the [STEER #2, CASTELL, p. 127] parts! That's interesting. Always was amazed at all the hide that cattle had on 'em. Got so much skin down there it's in folds.

I look at cattle, you know, and I don't look at all the little details. Well, I do sometimes. I do look at the little details when I'm buyin' a bull maybe. But outside of that, I don't look at all the little details.

[STEER #3, CASTELL, p. 83] I was scratching one of my bulls the other day. And he came right up to the fence to where I could look him right in the eye like I'm doing here in this picture right now.

What's always amazed me about these cattle, or any cattle—I've had bulls, in fact I've got one now out here that I guess he'll weigh over a ton—and what has always amazed me about animals like that is how quick they are. They're as quick as a cat.

I can't imagine an animal that big reacting as fast as they can react. You oughta see 'em when they fight. They'll never let one get on the other side of 'em, you know. Their actions are so quick and still so big. Now you'd think they'd have to be smaller to do that but they don't.

[STEER #14, CASTELL, p. 98] Yeah, lookin' him right in the nostrils there. That's a good one. That's another thing they have is such good smell. Oh yeah, they can sure smell feed a long way. Yesterday afternoon I wanted to get those three bulls outta that field cuz I had one there that was a calf that I'd kept and I wanted to brand him. And so I drove my truck out there in the field and rattled some feed in a sack, and they were as far as those cattle are over there in the creek now which is a pretty good piece. And directly here they came. After so long a time, that wind had caught that smell and it carried it down there and to them, and they could smell that feed. And here they came.

I've always said that's the easiest thing about ranching now. You ranch in a truck. Just drive out there and holler 'em, call 'em up, and here they come. Why, I have a horse. I still ride. I rode it this morning. I can't do without a horse. I've ridden horseback all my life. And I guess I'll have a horse till my dyin' day. In fact, I hope that's how I die is falling off of a horse someday.

Well I'll tell ya what, when you're as used to being—I love the land—through the years of ranching, you know, land is close to my heart. And I just can't—it nearly breaks my heart to see what's happening to ranchland now. Nearly breaks my heart. It's being divided up into ranchettes for so many people. And that's really taking the real ranching out of it, from my standpoint of view. And it just breaks my heart when I see something like that happening. And the ranchers are getting fewer and fewer.

Well, let's just face it, we didn't have enough land—we got a nice ranch—but we didn't have enough land for our children to stay here and make a living off of it. I encouraged 'em to get 'em a good education and find 'em something to do besides ranching cuz I'll tell you what, the way things are right now if you lived out here on a little place you'd starve to death. Your income just wouldn't be enough. You gotta have something else to do.

And that's why I say the pure rancher, the fella that really makes his livelihood and that's his only income, those ranchers are getting fewer and fewer. Most ranchers now, so many of 'em, either their wives work or they work extra doing something else besides ranch. It's just not there. The money's just not there. Some people say, "Oh look what you get for a calf." Yes, but that

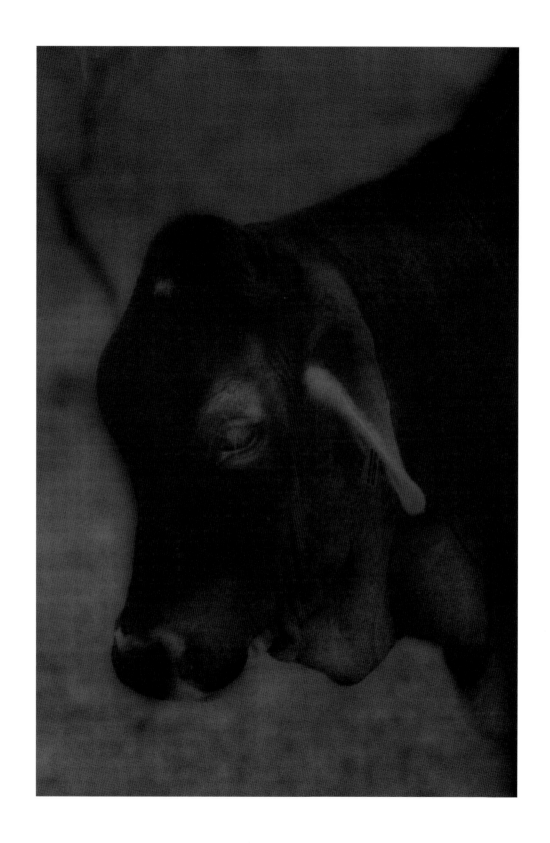

One of the things I like about this work is it makes you look into the photo and be in there with the subject. You can smell it. Color doesn't do this. Black-and-white makes you become a part of the photo. You can imagine the smells, the grass, the feel of the wind. It draws you into it,

if you are willing. **If you aren't willing to be drawn into the photo, you won't see beyond the surface. It will merely be a picture of an animal and you will miss the message there for you. There is a message in every photo. And the message is different for everyone.**

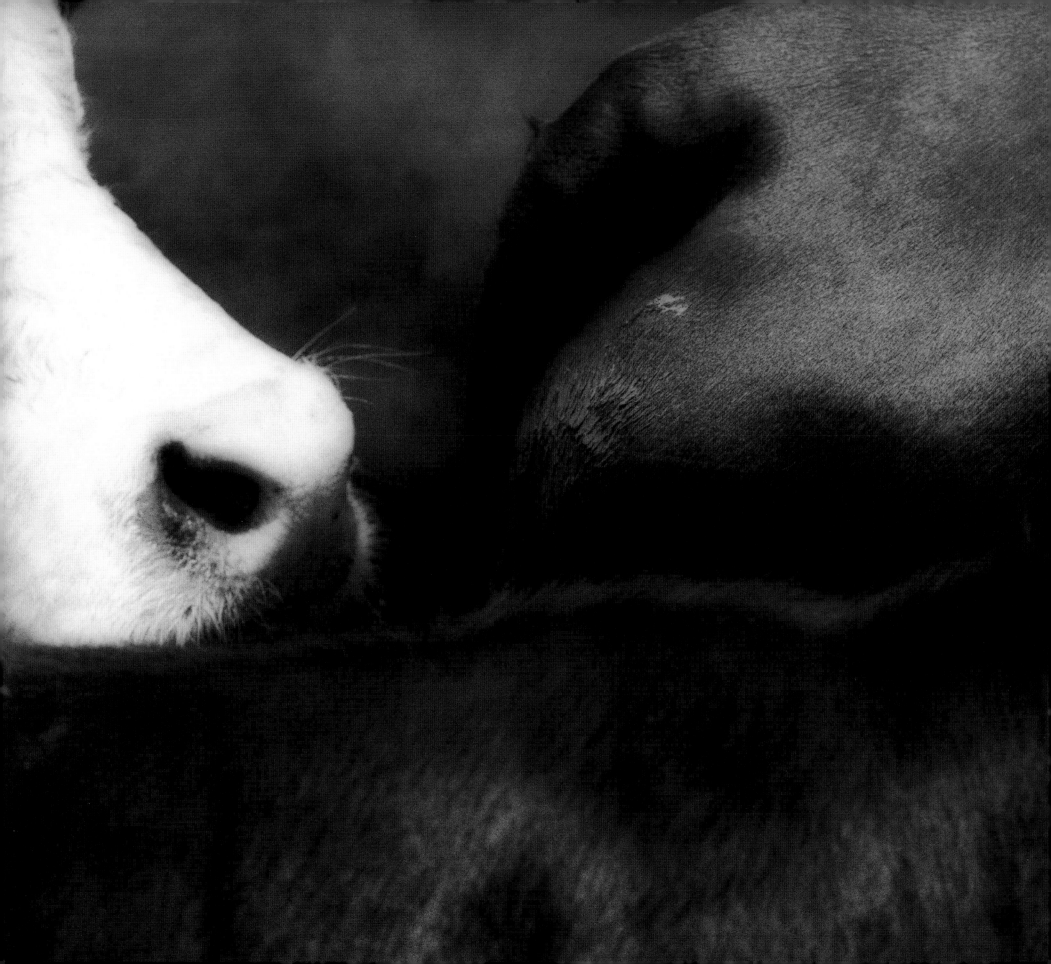

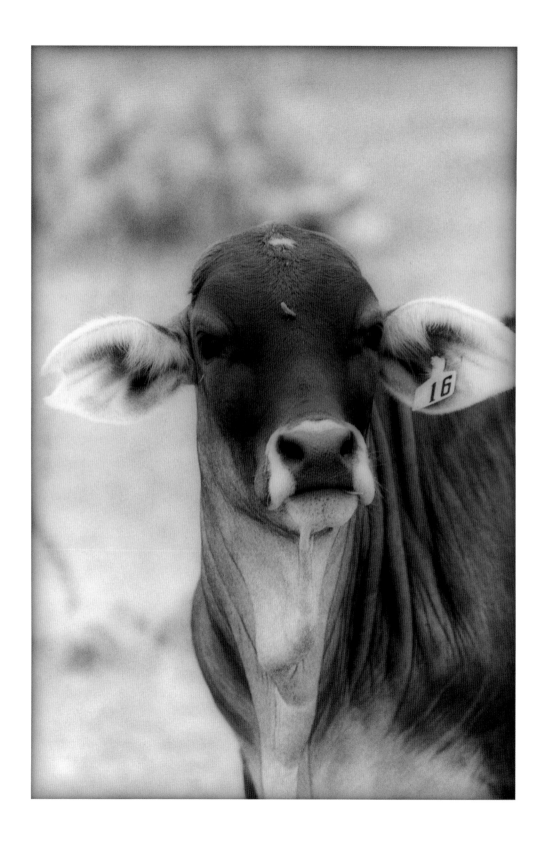

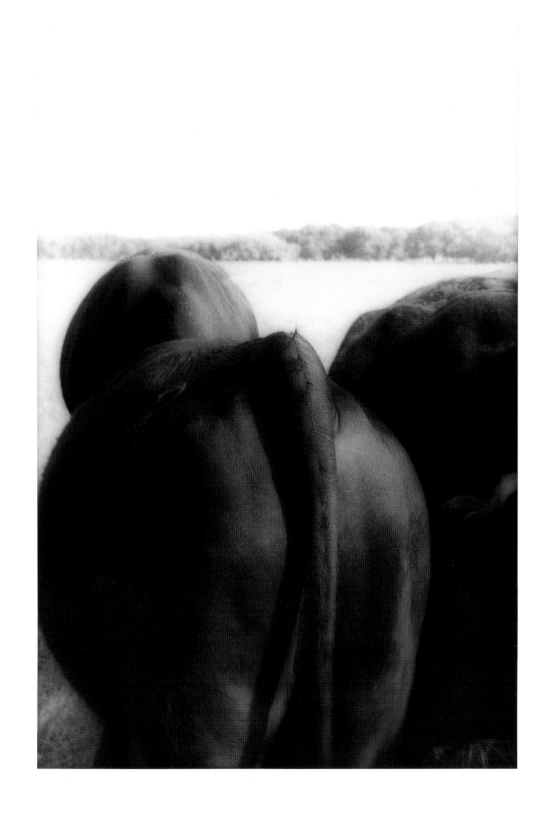

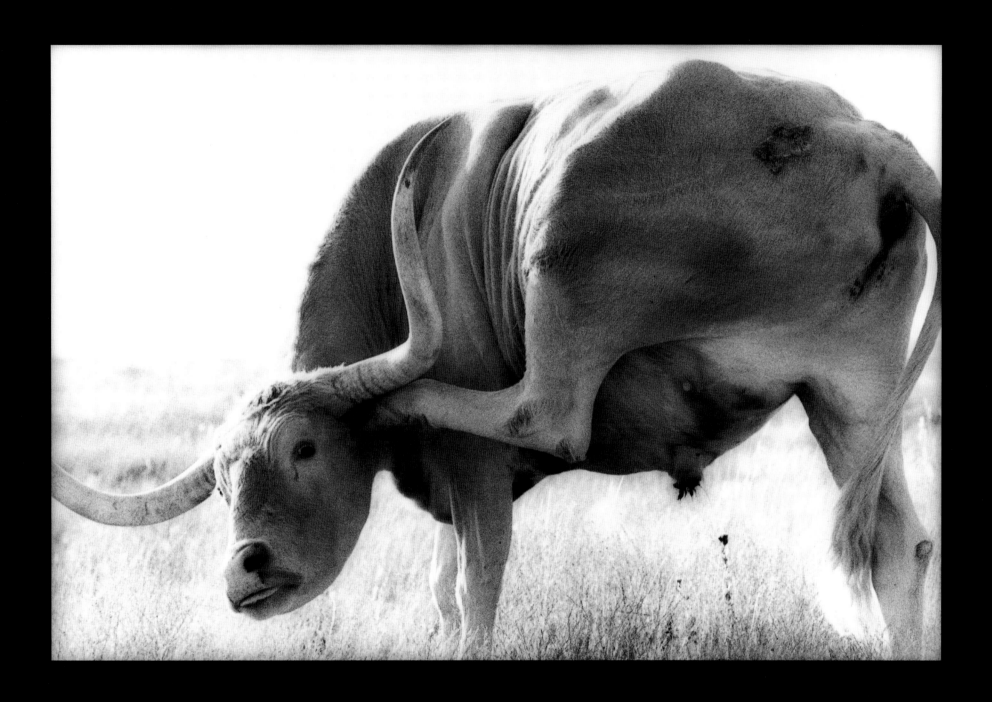

doesn't compare to the inflation that has taken place over the last thirty, forty years for the things I have to buy.

I had two men to come out last week to work on that windmill, it was broken. They left at nine o'clock and drove up here and worked on that windmill and I paid 'em from the time they left. They fixed that windmill and got back to town. It was a total of four hours or a little better. And they put about forty dollars worth of materials in there. I needed leathers and something else in my plunger that pumps the water. And that bill was four hunnerd dollars. That's close to ahunnerd an hour.

Well, that kinda money is not in ranching. A head-a-cattle now—I sold some the other day—they brought seven hunnerd dollars a pair—for a head-a-cattle—which is a lot. But not when you compare to what those men got for four hours work. That's why you cannot make the money it takes to keep a place going off the livestock you sell. You just can't do it. And that's why so many people have gone to this exotic ranching. That is extra income that they don't have any expenses on, relatively speaking, cuz it doesn't take that much to keep those animals in their pasture. Their upkeep isn't as much as it is with a bunch-a-cattle.

This winter I fed those cattle. And it cost me about a hunnerd dollars a head just to feed 'em from January till now. Three months. Took a hunnerd dollars a head. And now I've got to start spraying 'em with an insecticide because the flies are getting so bad. And that will keep 'em from putting on a good gain if you don't try to keep some of the insects and flies off of 'em. So that's another added expense. And then it'll be worming, and you have to worm 'em once or twice a year because they get internal worms and then they won't put on good weight. You have to keep 'em clean of internal parasites. So there's always something.

And fencing. I had a little done this last year. A half-a-mile-a-fence right up there this last year cost me about five thousand dollars. Just a half a mile. And that's not very far. A bob [barb] wire fence, a pasture fence is what it was. It's out there a piece. Fencing costs you at least two dollars a foot, running foot. And you take five-thousand-two-hunnerd'n-eighty feet in a mile, that runs into a lotta money.

[STEER #1, BLUE MOUNTAIN, p.105] Now there's another Texas Longhorn, looks like. Ugly critter, idn't he? I think, anyway. Oh they're interesting to look at, I agree with that. But I wouldn't want one on my place. I've heard too many stories about these Longhorn bulls. They say they're the hardest thing in the world to keep in a pasture. I guess they were that way from their origin. They just roamed anywhere they wanted to roam.

Well, it's just a shame he didn't come out here and take a picture of my good black bull. No, I'm just talkin'. Just at a glance, that is one of the best crosses that they tell me there is now. It looks like that cow and calf is a cross between an Angus and a Hereford. That's why they have what I call a bald face, a white face. That's in the Hereford breed. You know, the Hereford cattle have white faces. And it looks like that is a cross between two breeds. And they're good cattle. Those are very good cattle. My father-in-law had a few here one time. Black cows with a white face. [COW & CALF #6, MASON, p.65]

[BULL #3, ROUND MOUNTAIN, p.77] Well, I don't know about this picture. That just looks to me like a critter. You can even count his ribs. It's alright when they're rounded like that. Now when the skin is too close to the ribs, when they look like a skeleton, that's when it's bad.

[BULLS #1, ROUND MOUNTAIN, p. 86]

Now see, these pictures were taken, it looks like, when they had on their winter coat. They got long hair on 'em. You see, come about May or June they'll have short hair on 'em. That's when they get slick and shiny. They lose their long hair. My horse, I rode my horse this morning, and when I unsaddled my horse all that loose hair he had on him was stuck to my saddle, I mean in wads, in handsful. My horse is losing all-a-his long hair too. But they've had a good spring, see. It's warmed up and the green grass is comin' and that long hair falls off of 'em. Same way as cattle.

It's not that I don't like Longhorns. I don't mind lookin' at 'em but I wouldn't wanna own one, no. [STEER #1, BLUE MOUNTAIN, p. 105] But I don't mind lookin' at 'em. I think they're interesting animals, they really are. One thing I really like about 'em, and I *really* like about 'em—I wish the beef breed had more of that—is their stamina and their toughness. They're tough. They get by on very little feed, too. They can get by on nearly anything.

Do you know they used to run so many of them in South Texas, I understand, where the pastures weren't near as lush. And they depended on brush. They had a lotta brush down there that they could eat. That they *liked* to eat. That's what this looks like.

Yeah, that looks like my Jersey cow that I used to milk. You know, I milked a cow for forty years. So we had our own milk. My children loved milk. Of course, I took those cows to the vet and had 'em tested—for all the diseases—tuberculosis and I don't know what all. Anyway, I milked a cow every mornin' and every evenin' I milked a cow. I did that for forty years and finally I told my wife, after we got on our own, I told her, I said, "I'm quittin'."

And see, she came from German origin like I did, and she would make cooked cheese and she would make cottage cheese and-a-course she churned her own butter too—and all that good heavy cream. But boy, you can't stay on it unless you do a lotta work or else you'll get fat.

Yeah, we lived off the land more or less so to speak. We had our own meat. Had our own milk. Had chickens. Had our own eggs. She always planted a garden. Had a garden of vegetables. Poor ol' girl. She's worked too hard all her life. That's what she wanted. We were more or less self-sustaining, so to speak. To a great degree. Not like they were years and years and years and years ago. Course you know, when my ancestors came from Germany over here, about the only thing they ever went to the store and bought was flour and sugar. They didn't buy anything else out of a store. And that's another thing. These children—these kids that are raised nowadays—they think a can-a-beans, say, your green beans, comes from a store. They don't even know beans grow outta the ground.

If I had to do it all over again, I'd do it again. Just like I did. I'd change some hard times. But I don't know. I really think sometime it wouldn't hurt for young married couples to see hard times. I think that's probably what's wrong with a lot of young people nowadays. They don't know what hard times are. I firmly believe that. When I hear somebody complaining about the way things are I tell my wife, I say, well, I told her several times, I say "What's wrong with young people nowadays," I said, "they've never seen hard times."

I have these switches in my head. One is the art critic switch where I just start talkin' about the art here, which I tend to do very easily. But the other one would be the nostalgia switch where I can try to remember a little bit what my historical connections are with the cattle industry and all of that.

Just seeing that landscape in general takes me right back to Wilbarger County where I grew up. It looks a lot like this without the mountains. It's totally flat but it's covered with scrub mesquite except for the places where the farmers took it out to raise wheat. It was prickly pear cactus and mesquite trees that came up from Mexico. When they would bring their cattle up from Mexico to take them to market in Kansas City or wherever, the cattle would deposit the seeds all along the way. All these mesquite trees got in Texas that way.

This is just like the area south of Vernon. It's scrub dry brush. We didn't have cattle like this except in the rodeo. This looks like a Brahman. I used to go sell cushions and programs at the rodeo to get in free. And then me and my buddies would go sit over the chutes where the bulls would come down for the bull riding and we'd watch them go underneath us. And Brahmans were some of the bucking bulls.

[BULL #1, MARFA, p.131] So that's where I kinda fell in love with the shape of these things—their form. So that's another memory that is meaningful to me. I think I loved the sculpture of that kind of cattle even as a kid. But that's a pretty classic Texas scene right there. The bull standing looking out over the barbed wire fence. Hmm.

This is one of my favorites. Cuz this one triggers the artist in me more than the Vernon boy because this is so abstracted and so mysterious and surreal that it goes somewhere deeper than just memories of rangeland. It goes into some more archetypal kind of wiring in me that has more generally to do with Creature than with just the abstract beauty of sculptural shapes. This would make a beautiful gravure.

The aesthetics of this—other than the way light is working, which may be the first thing that grabs me—but almost as quickly or maybe simultaneously with me, what grabs me is the monumentality of the form. Because it looks like it could be on the scale of one of the Egyptian pyramids. It's got that kind of mass and sense of scale, that sense of monumentality that appeals most to me.

These forms in a way are architectonic. They're like big structures. He takes an organic [BULL #6, MARFA, p.93] form and he converts it into architecture. I like that a lot. At that level, it becomes a kind of monument to Bullness, a monument to Cattleness. So that, again, takes you into a deeper level than just a picture-of-a-bull. It's more archetypally connected for me.

This is more literal in its rendering of the landscape and the bull, but one of the things I love about it is the symmetry of it, along with a little supportive asymmetry. It's very iconic in its sense of verticality and sort of vertical gesture that's reinforced with the windmill. But the way he's caught the bull with its head down and then the way the light sort of bifurcates the form, again vertically, the whole thing becomes like a Byzantine icon in the way that it's

composed. Which, again, brings a kind of a special, almost sacred kind of attention to a subject which is so mundane in this part of the country that you would tend to miss whatever meaning could be indwelling in simple forms like this.

I read one time a book called *Theology and the Arts*. The author mentioned how artists—this wasn't his words, but paraphrasing him—he said something like artists can celebrate the incredible *whatness* of things. Just the simple fact of their tangible existence is something full of glory.

I find that in this work a lot, too, that he takes something that most people miss the glory in, miss the sacredness of, and then sets it up in such a way that you're led to find intrinsic meaning in it that's deeper than just the level of whatever it happens to be. So there's just the incredible whatness of that bull that is highlighted.

I think the way he does these images invests or at least reveals the kind of metaphysical meaning that resides in all things, really. And he just chooses these objects to focus on and lead us to that level of meaning for these particular objects that he's showing us.

Classic. In images like this one, we're also connected up with really ancient images of sacred bull images like those you would see in Mycenaean or Middle Eastern art. There's just a whole lot of power resident in that form. I've always been frightened of these animals because they are so powerful and I've seen 'em hurt people in rodeos. But I always have respected their strength and their power and their beauty. [STEER #3, ART, p. 103]

[COWS #1, HIGH PLAINS, p. 39] I'm drawn to the sky as well as the cows. I can sort of feel the atmosphere there—one of those sultry days in the summer when you're lookin' for shade and hopin' the sky will coalesce into some rain clouds. But here it's nice the way they echo the shapes and the colors of the cows. I miss being in that landscape. And when I get in it, if I drive through it even briefly, it renews me. It's a place where I can go to be renewed and re-created.

In this photograph, it's the landscape. I like the combination of the wildness of it—which is kind of a fantasy cuz it's all cultivated—but you get the sense that it's pretty relatively wild land. But then you have these tokens of order—like the barbed wire fence and the grid of that. And the parallelism of that imposes this little curtain, this layer of a sense of order over that rough landscape and over those organic forms.

I love this one. It reads that High Plains landscape so beautifully. This one reminds me of the original bovine inhabitants of that land. Looks kind of like a buffalo. Again, the way that sort of fence line cuts up that land into surveyed right angles. And there's that fabulous animal completely oblivious to the meaning of any of that. He doesn't care whose land it is. [BULL #1, HIGH PLAINS, p. 72]

Now here Burt's pushing to the logical extreme—just seeing how far he can go with his abstraction because this is getting closer to the edge where—one more step or two beyond this—and then you really couldn't figure out what the image was, I don't think, unless you were told. It's getting to the point of erasing the literal image and I could see him playing with that and pushing that even farther just to see what happens. [STEER #3, CASTELL, p. 83]

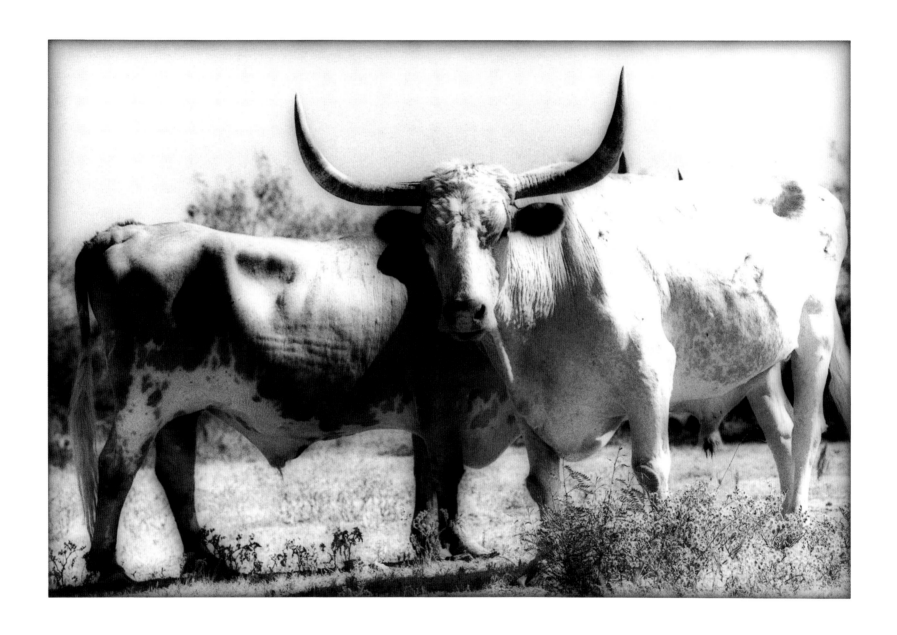

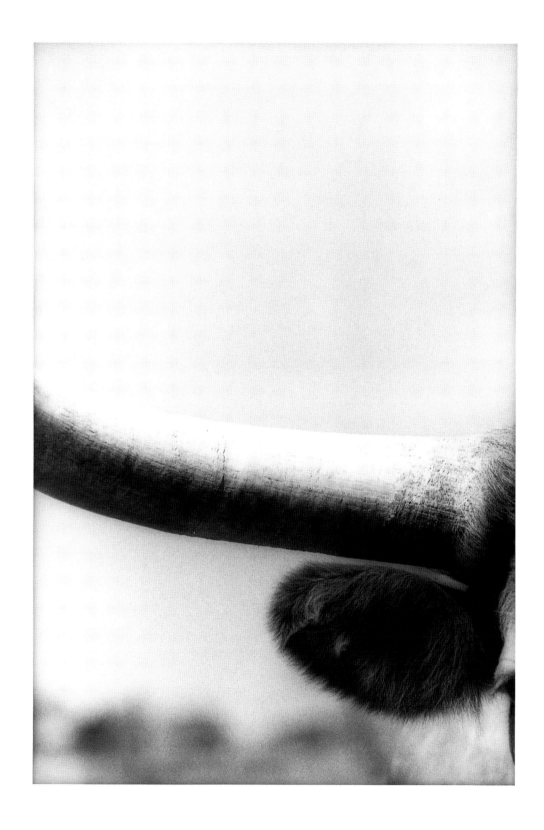

Ha! That's about it alright. Man! For me his work is about wonder. You just look at that and [STEER #4, CASTELL, p. 119] you realize, "Well yeah, that's always been there and it's always looked just like that." And some of us, those of us who are lucky enough to be sort of artist types, poet types, creative types, we see things all the time that are like this that just capture us, and just stop us in our tracks because it's so fascinating.

But I think the average person misses that experience most of the time. You know, that sense of wonder about just something so mundane and simple as this—the nose of this bull. And he pulls it up and presents it to all of us, really, but especially to people who don't tend to notice. There's a whole world of form there just in that one little six-square-inch place. I guess it was William Blake that talked about seeing the world in a grain of sand. I think that's kind of the spirit, for me, he's up to here.

I think this work kinda slows down time. Photographs always, I guess, are a capturing of a split second in time, and their freezing of things. But in his work, I don't think of it as freezing it so much as just reeeeeally slooooowing it down so that you can take the time to soak it up. I think that's part of the peacefulness of 'em too. When you look at 'em, for me, I think my heartbeat rate decreases. I think it sloooooows me down. It says, "Just stop and take a minute and just look." And that's a rare thing—in my life. I think it's a rare thing in our culture.

[COWS #21, MASON, p. 9] For me this image is a symbol of Creature. That could be a cow. That could be a camel. It could be small or it could be huge. It doesn't so much matter but it's a symbol of Mammalness for me. That little tuft up there. And then beyond that becomes a landscape. And you can just go on and on.

[STEER #7, ART, p. 40] Now this one does something not too many of them do for me but that I think is very exciting—it becomes cinematic. I mean, this one really is in motion. It's that texture in combination with the movement, the gesture within the form itself. It's almost like sea water. See the movement in it? And this becomes very landscape-like. The whole thing, even as a bull, is moving for me and there's a vibration in it and a movement in it that feels like a still from a black-and-white movie of bulls.

There's something brutal about that brand. It just reminds you that this is stock, this is [STEER #2, BIG SPRING, p. 55] staple food on the hoof, born and bred as food material.

Look at the personality there. Like a portrait. It oughta have a name, and a family, a history. [STEER #17, CASTELL, p. 132] Cows and bulls throw me because I keep wanting to read this sorta peaceful personality into 'em, and kind of a certain depth of feeling too. But I also keep reading and hearing that they really are pretty dumb, simple animals that don't bring a lot of brain power or sentience to their existence. But, who knows.

That is so monumental. Wow. There's a mystery about why these work that I haven't actu- [STEER #1, BLUE MOUNTAIN, p. 105] ally figured out. I mean, I've figured out a lot of the stuff I've said already. But one like this just reminds me there's a magic in it that's all his, that I don't begin to understand why this

works so much more powerfully than some other picture of this bull standing out there with some old tires around. I mean, I wouldn't have thought that it would've carried. It would just've been sort of an ugly picture in a way. But somehow he—I guess it's the way he lights it, and certainly the way he composes the whole frame that invests it with this kind of magic. It's like a heavenly spotlight is on it.

That's one thing about these. Because the images are presented to us in this form, all the other distractions are removed. The unbearable hot sun. The flies. The smells that are there. All the different sensory distractions are gone and we can just focus right on the power of the image. And that's a gift that I think artists give to viewers in their work is the privilege of removing distractions.

Look at the sculpture of those things. They look like rhinoceros. They're so tank-like. God they're beautiful. [BULLS #2, LLANO, p. 134]

THEY ARE POWERFUL. How he caught 'em there. That one would have to be on my list. One I'd have to have around. I think, growing up where I grew up and all, as I move into my autumn years, I think I'll definitely have to have one of these just to sorta remind me of my roots.

I'd like to give these to my family members as gifts because it brings up their own imagery that's around them every day but presents it in a way that takes them to art over a bridge that they understand.

Well, I guess, in the end, the most effective thing is he responded so directly and genuinely to what's around him in terms of the landscape and these creatures within it. He just focused on 'em. Sounded, from what I've heard him say, it's been like a calling. A surprising one, in a way. I mean, you know it's not as if he has cowboy in his history or anything. He just kinda stumbled on this. He paid attention. He's awake. And that gives it all the more credibility to me.

It's become like this sort of calling that he needs to do almost against his wishes. "I don't wanna be a cow photographer." I can just hear him saying that. But it's like, "Okay, I've been given this task and, by gawd, I'm gonna do it well." So he focuses. There's a discipline in that that I admire a lot. I've always thought of his work as being kind of Zen photography, and thinking about it and talking about it has given me more clues about why that feels that way to me, that sort of meditative focus that you get—least I experience it when looking at these things. For me that's even a more powerful part of my experience with this than the nostalgic part, the history part.

M aine-Anjue. A-N-J-U-E. Ann-joo. They're French cattle. I don't know if that's what this is. But I wish I had a pasture full of 'em. Last year it was sooo dryyy. I had six black Brangus heifers and two red ones and it was so dry that when I pulled the calves off of 'em, I had to sell 'em early because those calves were sucklin' the cows down and they didn't breed back. Now you talk about somethin' that's a misery. Tryin' to feed 'em to get 'em back on their feet enough to put on a little weight and then they just won't breed. [STEERS #19, CASTELL, p. 87]

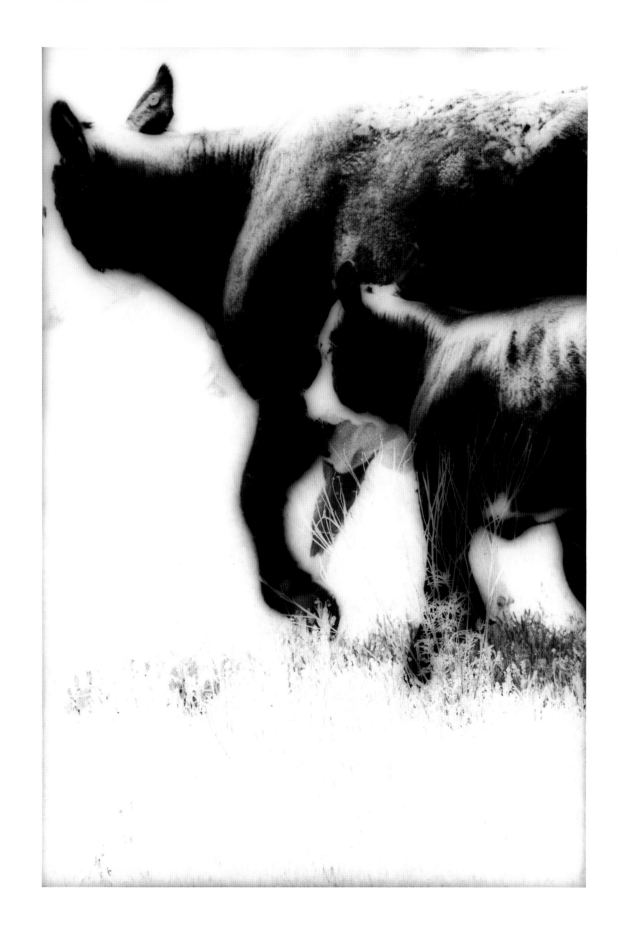

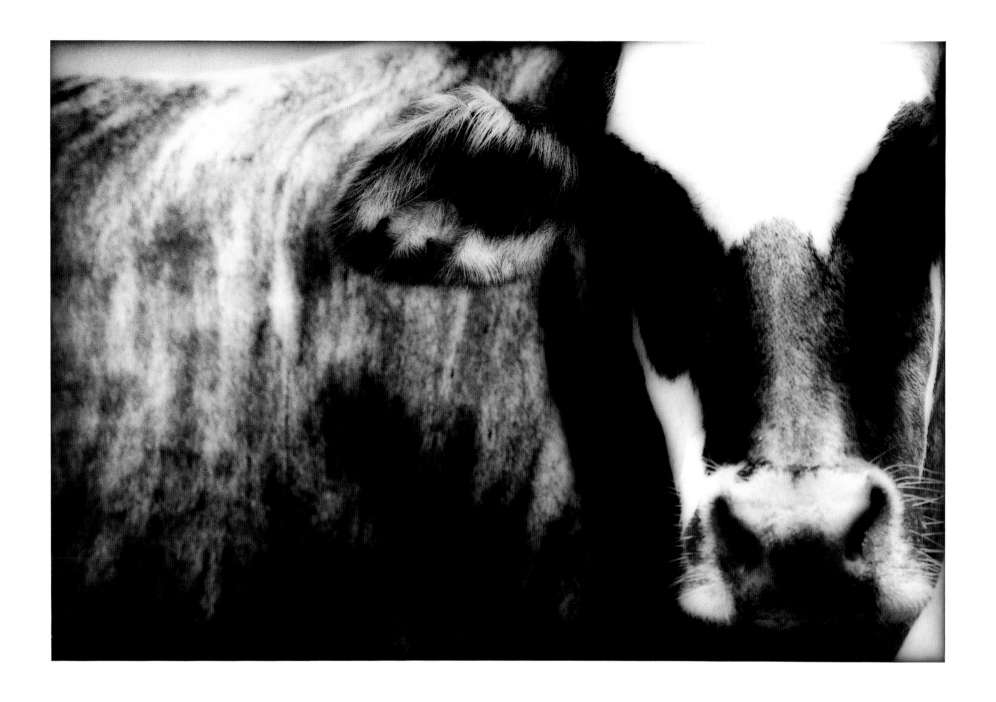

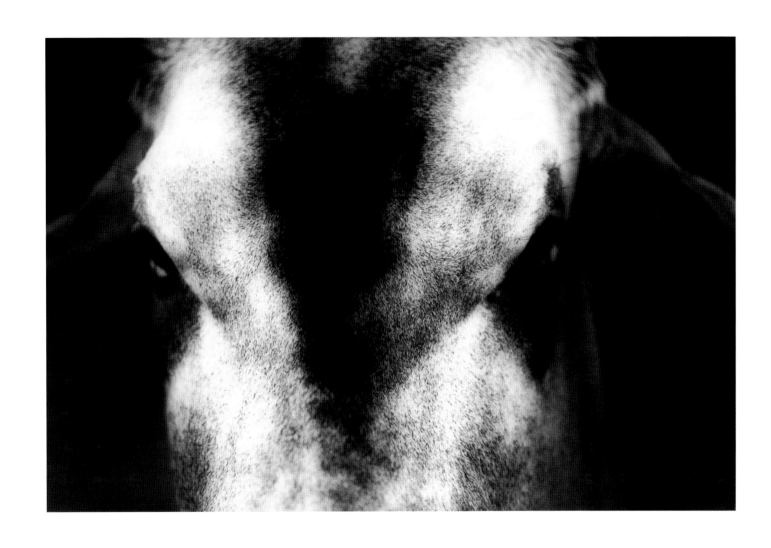

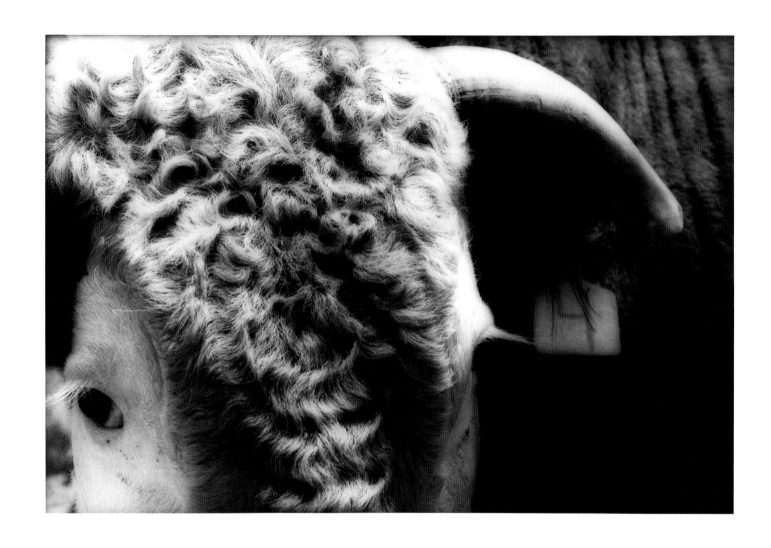

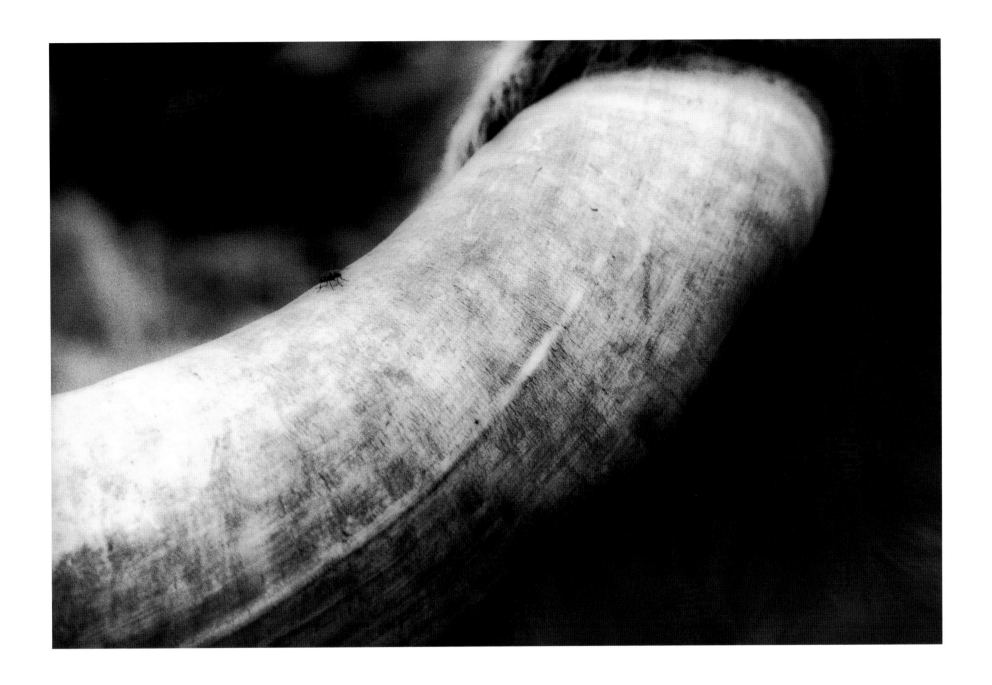

But I was fortunate with my little handful. I fed 'em peanut hay and hay grazer. And I feed the square bales. I don't feed the big round ones cuz I don't have one of those big ol' trailers that scoot under there and kick it up. Those big ol' round bales of hay, some of 'em weigh twelve hunnerd pounds. I tell ya, it's a hard row to hoe if you're gonna make your livin' outta the dirt, that's for sure.

Some people can be around cattle and be comfortable. I can tell this photographer was. Now I have a friend whose son can get around them and if there's a cow in the pen, they'll run clear to the other end. If you're not careful they might just jump the fence. And he's a dayworks. I wouldn't want him dayworkin' mine. A cow is kinda like a horse. You hit one at the wrong place at the wrong time and you got problems. You got to work 'em slow and take it easy with 'em.

Well, the Good Lord put me in the wrong place. I wished he'd-a-put me in the middle of a big ranch with a pretty blue mare and that sorta thing. That's where I wanna be. I like cows. Like goats. Like sheep. I like bein' outside. But—I guess I'm just glad I got a little place and got a few cuz I could've gone along in this ol' world and not had one.

Those are Brangus bulls. They're black. And they got that hump. From the Brahma. And the black comes from the Angus. But the Angus had a lotta short-legged ones. That's why they used them to cross-breed because they're short-legged. But you can get 'em too short. We had one, one time. Old cow had a baby and it was short-necked, short-legged, we butchered it, best meat I ever ate— that little ol' black calf. [BULLS & COWS #12, MASON, p. 3]

My little handful, I don't have but fourteen mama cows and the bull. And that's on a hunnerd-and-sixty acres which anybody else'd prob'ly think is overstocked but I'll tell you one thing, they're just as fat and purty as they can be. Now our fields the last five years have been just terrible. The dirt lice were bad. They killed out the improved grasses. And I don't know if it'll ever come back. I'm 'fraid the roots are gone and we'll have to re-sprig our coastal fields.

But maybe the Lord has a way of takin' care of some of that stuff. If not, I've got about, let's see, thirteen, twenty-six, thirty-six, 'bout forty-seven, forty-eight acres of improved grass. And I'll have to re-sprig ever last bit of it if it dudn't come back.

Now I've not been feedin' my cows, I guess, for a month or six weeks now. Just a little cake now and then. It's just a matter of callin' 'em up and throwin' a few cubes out there and they'll go out and pick up one or two and chew on 'em and it keeps 'em gentle. It's cotton-seed cake or range cubes. This way they know when they see ya comin' they're gonna get sumpin' to eat. They won't run off and go the other direction. It's just like feedin' a dog or a cat or anything else. You can teach cattle to come up. Or you can get you a long stick and work on 'em a few times, and first thing ya know, you won't have any cattle comin' up to the pen. And they get used to one person. Mine can even tell when a stranger comes by the house. I can change my old outside hat that I wear and I better talk to 'em cuz they'll just look and look at me and think "Well, who's that in the white hat?" You know, they look at'choo like they see a stranger. They don't like that.

It's really been a challenge to hang on during what we've had in the last five years. But that husband-a-mine told me, he said, "Don't get married to those cattle." He said, "When it gets to where you haven't got that barn full a hay, get rid of 'em. Put your money in the bank and leave it there. You may wanna buy 'em back later."

Because you can just feed and feed. And a lotta people owe for their cattle. And then they put all this feed in 'em and then that ol' cow she don't have a baby. And it'd bring maybe four-hunnerd-and-fifty dollars on the high end. Some of 'em can keep 'em till they weigh six-hunnerd pounds, may bring in a little more money. You can't pay the bank interest on your cattle and do all this feedin' and if you don't own the land—well, the costs are just prohibitive.

Now I don't owe one nickel on my little handful a cows. I don't have to make a Federal Land Bank payment. That little piece-a-ground is mine. I keep the taxes paid on it. I work five days a week for the Farm Bureau and I spend my money to buy feed but I also watch when the hay starts comin' in. I've got neighbors that have extra hay and they see that I keep my barn full-a-hay. And if I hadn't-a-had that barn full-a-hay, I'd-a-been in trouble this year. Cuz nobody made any hay.

Now I prob'ly got two-hunnerd bales or so still in the big long barn but then, what I'm doin' with that, I'm tryin' to get all of the old hay to one end and put the new hay in, and feed the old hay off. Or the first thing ya know, you keep goin' in there and puttin' your good hay on top of it and feedin' that off, you're gonna have hay that's gonna be six or seven years old on the bottom, and your wire will get rusty, break off, and you know—it's survival. That's the name of the game.

And if you can't do the work yourself you're in trouble again. Pay somebody twenty-five or thirty dollars a day to come out and feed? Why, I take my feed home in that little pickup and I take that five-hunnerd pounds a bit at a time and I carry it outta the pickup and put it in the carhouse. And then I pour it up into five-gallon buckets and it's a little easier to carry. You just have to learn to cut corners and do for yourself and when you get to where you can't do that you might as well get rid of 'em because there's not enough money in it. Or your neighbors'll come help ya but nobody wants to impose on the neighbors like that. Not when you're a widow woman. They gotta make a livin' just like everybody else.

[STEER #1, ART, p. 43] Well, now look at that. Those kinda people have made their money somewheres else and can stick it in cattle and just sit around and look at 'em. Now me, I don't have fences for that kind. Those Longhorns'll go through most any fence. I've got my little ol' Brangus heifers—young cows, they're all about the same age. And they don't have horns. And I'm not afraid of 'em. Now, I make the bull stay back cuz you don't ever wanna make a pet outta one of those outfits. And it's not that they ever mean to hurt'cha. If you put cake in your hands, stand out there and do like this, they'll eat it outta your hands but you gotta watch. If you don't, you're gonna get hurt. And those black ones'll kick ya twice while you're thinkin' about it. You walk by 'em and they're maybe grazin' and they see somethin'. Wham! There goes that leg! I've never been kicked yet. I've kinda *brrriipp*—felt the breeze a few times.

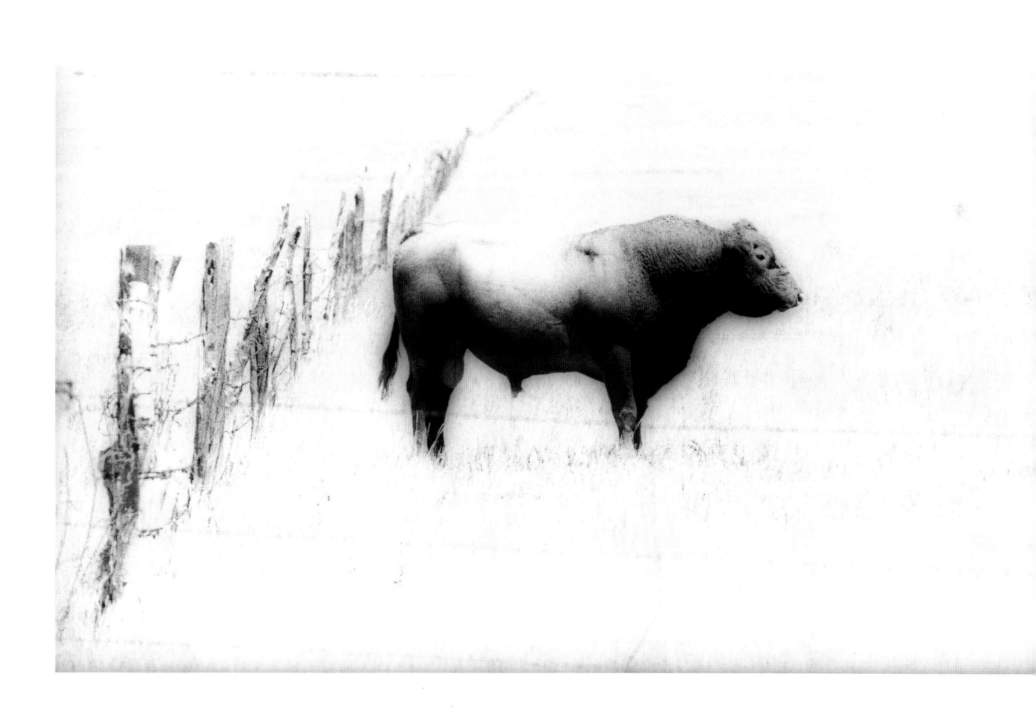

[COW #4, MASON, p. 109] Got a good sound bag. I wish I had her. Looks like she's ready to domino. Or maybe she's already had her calf.

[BULL #22, MASON, p. 68] We don't brand our cattle. I don't mine. They get an earmark. Heifers to the right. Steers to the left. But out in West Texas they always had pumpin' oil wells, purty horses, and fat cows. They could all graze together pretty good. You didn't have to worry about a lotta other things if you had that pumpin' oil well.

But we didn't have that. Daddy taught us how to work when we were little. That was back when it was the Depression. He worked for a dollar a day with four kids to feed. All day, and part of the night. We didn't know we had a daddy hardly. He'd leave at three-thirty in the morning on horseback. He didn't even have a horse trailer. He rode his horse across the range and one-a-those pastures had five thousand acres in it.

So you know, when you come from way back then, people can talk about hard times now but they don't know anything about hard times. But I don't wanna go back to them good ol' days. Not that part of it. Our poor little ol' mama. Washed clothes for people. And she didn't have a washing machine for years till she finally got her darned ol' Maytag, one-a-them poppin' things ran on gasoline. And she and my grandmother they washed no tellin' how many piles of clothes for other people. And did it with a rub board and used lye soap. Made their own soap. Survival. That was the way you made it.

My grandfather went to maybe the fourth grade. He was a carpenter. And there's no carpenter in town that could've figured a job and wound up with any less leftover material. Omama would fuss at Opapa. She'd say, "Well, there's not hardly enough to start the wash pot." He never went past the fourth grade but he had it up here. He was smart.

Our great-grandmother was captured by the Indians. She stayed with 'em over a year. Her older sister, they killed her because she kept cryin' and screamin' and the Indians wanted her to hush. And they scalped her and cut her tongue out of her mouth and killed her and threw her in a bush. And grandma stayed with 'em. And an old squaw that was in with the Kiowas took her in. And she made friends with her and that old squaw helped her get away.

My folks never asked for a thing. They worked hard, paid their way, and when they died they didn't owe anybody one red cent.

--

When I look at this work it's so serene. Nothing fights for your attention. It's striking. The ramshackle fence and the power of the animal. He could demolish it. Yet he's standing there peacefully and willing to be bound by it. You know, you have to be wanting something to stray. Like people. If we are lacking in something or have fear, that is the only reason to cross a boundary. [BULL #1, HIGH PLAINS, p. 72]

Why scratch with a back leg and not the foreleg? It's off balance. It's not logical. [COW #4, MASON, p. 109] Well, some things in nature aren't logical. Here, the back part of her is the biggest part of her and yet she uses half of her support to scratch her nose. This isn't logical. It calls you to think about the created order. It's bewildering, isn't it? It gives you a hope and a belief that something not logical can function. I think it makes you have to look beyond the obvious. So the question about Nature is, "How does it work?"

One of the things I like about this work is it makes you look into the photo and be in there with the subject. You can smell it. Color doesn't do this. Black-and-white makes you become a part of the photo. You can imagine the smells, the grass, the feel of the wind. It draws you into it, if you are willing. If you aren't willing to be drawn into the photo, you won't see beyond the surface. It will merely be a picture of an animal and you will miss the message there for you. There is a message in every photo. And the message is different for everyone.

What's going on here? What are they looking at? His photography is so great because he doesn't give the whole picture. So I get to fill it in. I get to complete the picture. So it almost gives me part ownership of the photo because I've completed the image by what it speaks to me. It's very personal. And I get to partake in it. An artist that gives you all the information is not as interesting as this because of my part in it. I think good art comes *from* people. But great art comes *through* people. That's why I think this work is great.

I can remember in high school I was in a speech class and my assignment was on [COW #27, MASON, p. 66] President Roosevelt's inaugural address. Well, I didn't want to practice in front of my family. I was afraid they would make fun of me. So I went out into the field and practiced on the cows. They just chewed their cud and looked at me while I gave my talk. This is cow country. I bet the old ranchers will enjoy these pictures. Tell Burt he's a Texan now. We'll accept him as a Texan, now that he's done these photographs.

I came from Sweetwater. Actually, Sylvester. I was born in my grandmother's house. I loved her so much. She taught me everything. I even lived with my grandparents for one year. I just didn't see any reason to go home. So I stayed. She taught me how to cook. She taught me how to swim in the pond. She taught me how to float on my back in the river. She knew how to shoot and could bring down a hawk in flight. She had to, so it wouldn't get her chicken eggs. She knew how to do everything.

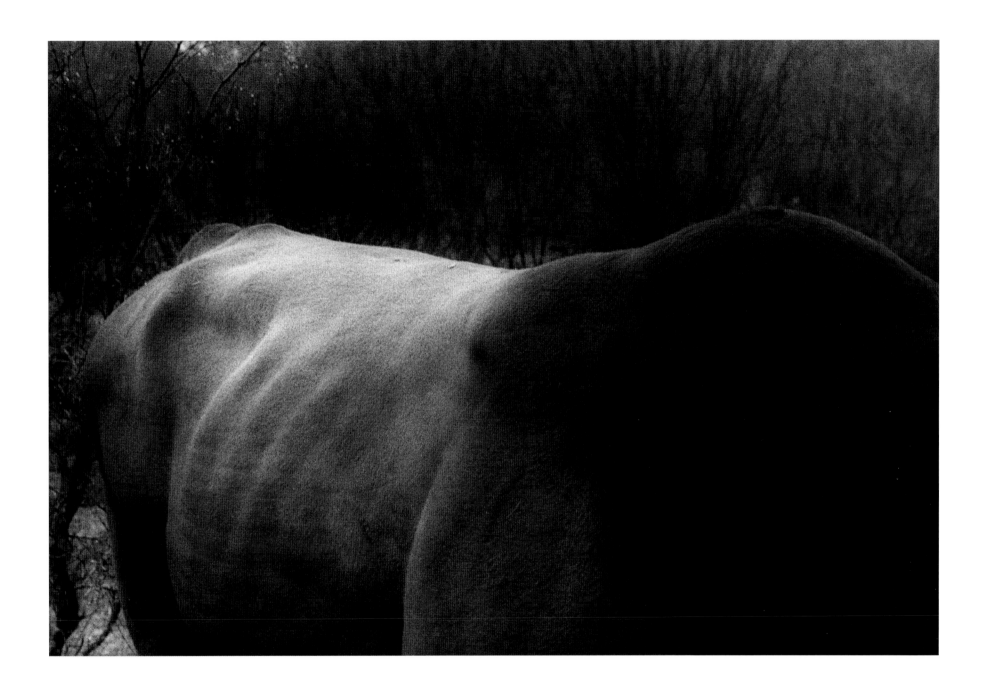

And then there were the cows, of course. Everyone had them. Even though my grandfather was a banker, he had land. He married my grandmother when she was sixteen and he was thirty-seven. They did that in those days. He was in Texas on business and he saw her riding her horse bareback, her hair blowing out behind her, she was barefoot. He didn't know who she was but he knew he wanted to marry her. And he did. But she told him she would marry him only on one condition. "I'll never leave Texas," she said. So he moved here from Mississippi.

[BULL #7, MARFA, p. 19] You know, looking at these I must tell you I don't eat much beef myself. I've always eaten lots of nuts. I let nuts do the job. My son had a cow he fattened up and I've still got most of it out in my freezer.

[BULL #1, HIGH PLAINS, p. 72]

The way that fence fades away reminds me when we drove to Rodessa [Ruidosa] a couple weeks ago and it was so foggy and you drive through all this farmland around Lemesa and there's all these big pivot systems, irrigation systems, and it was so foggy you couldn't see the end of the pivot kinda like the way that fence fades out.

[COWS #1, HENLY, p. 101] Boy, these don't look like cows. They almost look like a landscape. I grew up in south Texas in a town called George West. Ever heard of that? It's between San Antonio and Corpus. Near Three Rivers and Beeville and Alice and places like that. It's ranch country. Brush country. I grew up in town but my family ranched. It's really interesting to be around livestock and be up really close to 'em cuz when you're standing next to that animal you can really sense it. You can feel it breathing.

[STEERS #6, BLUE MOUNTAIN, p. 60] In church yesterday, it's funny, I don't know why this picture reminded me of it but my wife was sittin' back there, my wife and daughter, and a friend of ours was sittin' behind her and he had his arm like this around his wife. But I couldn't see his wife because somebody was blocking her so it looked like he had his arm around my wife. It was so funny. You know, I was the lay reader and so I was sittin' up there and it was hard not to laugh.

[STEER #3, ART, p. 103] Preparing for battle here. It really looks like he's ready to charge. I don't know if this is a bull, but bulls, when they fight, oh man, they make a mess. That's a

nightmare cuz they tear up fences, tear each other up. I don't know that they really recognize a mating season that much. I think they're always in the mood.

That's a really neat effect, the lighting on it. There's a baby on the other side. You can just barely see its nose. It's very dreamlike. There's a song, one of my daughter's little tapes, something about cows having a dance at night. If I could think of the words it'd be good for that picture.

[COW & CALF #6, MASON, p. 65]

[BULL #1, MARFA, p. 131] You don't see many of these around here. Marfa. A lonely fella in a lonely place. First visitor he's had in weeks.

One of my friends, when I was a kid, I'd go stay out at his ranch some. And they had a cow mounted in their house, a cow head, because the horns had grown out and crossed like this right above the nose. It was so weird looking. It can be a danger cuz sometimes they can kind of grow into the head. I don't think that happens very often.

[BULL #4, MARFA, p. 121] This cow looks almost like a goat. It does not look like that giant bull. In fact, it'd look like a mountain if that eye wasn't there. And look at the nose. Like snow on the mountain.

[STEER #6, ART, p. 41] This one almost looks like a rhino. You get a good sense of the mass of those horns.

Jumpin' around. Jumpin' around. Did he hit it with a hotshot or something? No? It's just a-playin'.

[BULLS #15, MASON, p. 26]

I think my daughter would enjoy seeing these. She's five. We've been here almost nine years this summer. When a job came open, I jumped on it. Took a guy's place who was here forty-four years. Not a lot of turnover in this town.

I've lived here all my life except three years in the Navy. We've always had some ranchin' interests, you know. I love it. That's my only life. Just to ride a horse and see mother cows have calves.

Used to most ranches here were from a thousand acres to twenty-thousand acres and now the average ranch here is four hundred acres. There's no big ranches like out in West Texas and like that. This inheritance tax would take it. If the father died, they'd pay inheritance. And then the mother died in two years, why then, they had all these big taxes on it. They're trying to appeal it, yes ma'am. Which we hope'll get done.

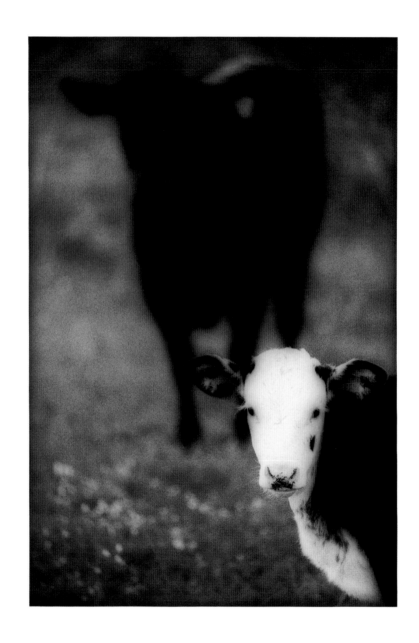

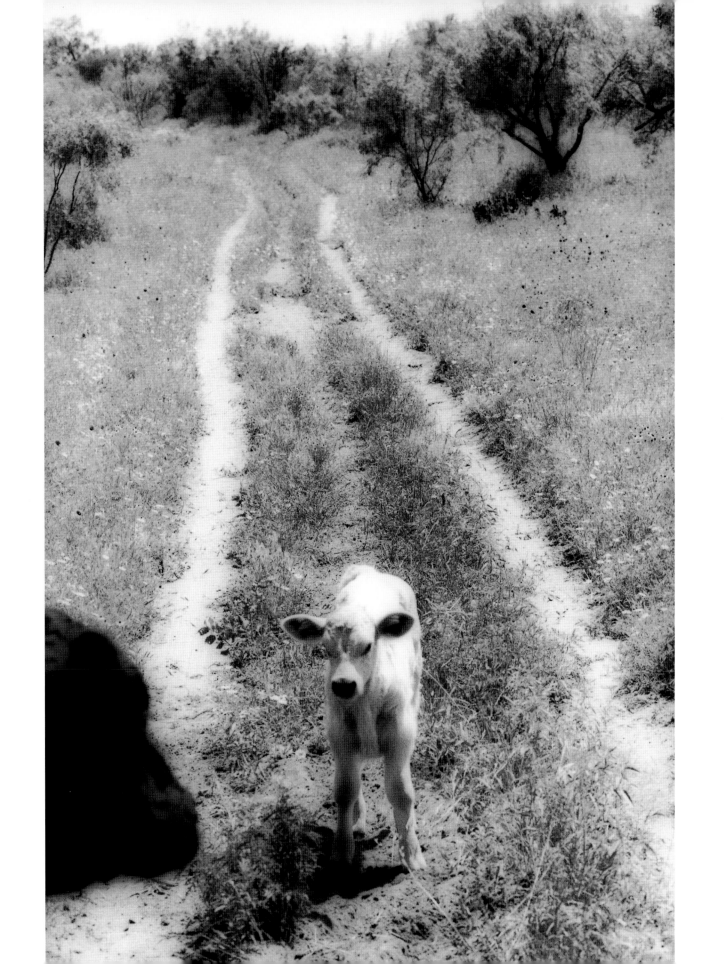

I've always said that's the easiest thing about ranching now. You ranch in a truck. Just drive out there and holler 'em, call 'em up, and here they come. Why, I have a horse. I still ride. I rode it this morning. I can't do without a horse. I've ridden horseback all my life. And I guess I'll have a horse till my dyin' day. In fact, I hope that's how I die is falling off of a horse someday. Well I'll tell ya what, when you're as used to being—I love the land—through the

years of ranching, you know, land is close to my heart. And I just can't—it nearly breaks my heart to see what's happening to ranch- land now. Nearly breaks my heart. It's being divided up into ranchettes for so many people. And that's really taking the real ranching out of it, from my standpoint of view. And it just breaks my heart when I see something like that happening. And the ranchers are getting fewer and fewer.

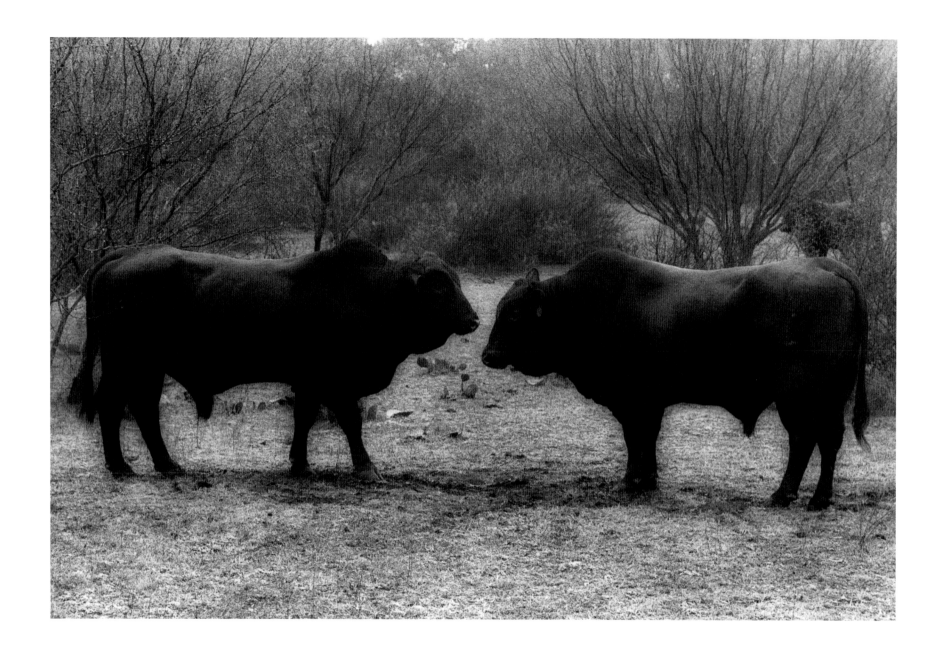

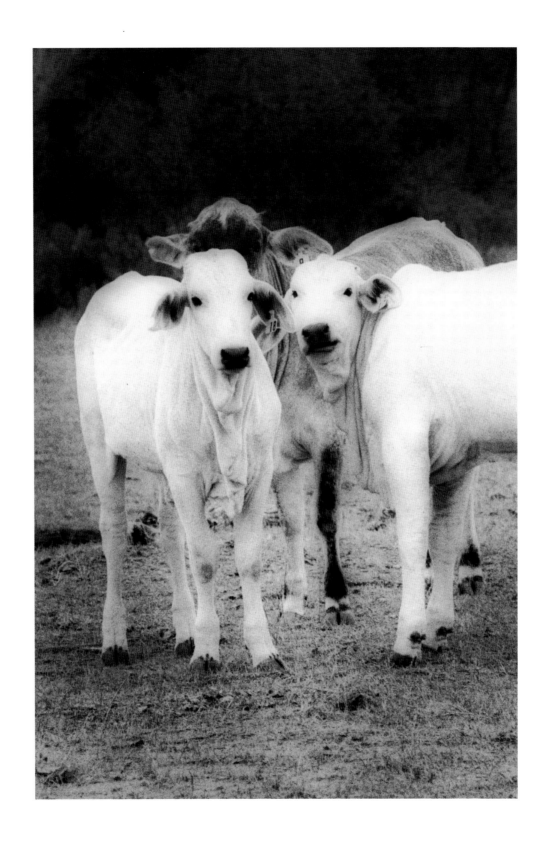

[STEER #1, GALVESTON, p. 27] You need a lotta land for cattle. Newcomers just don't get that. Sure, it's one thing to bring in hay and spend your money but it's water that ya gotta have. Ya don't have that, ya don't have nothin.' Haulin' water is no fun, I'll tell ya. Do you know how much water those cows can drink? They can go without food before they can go without water. Yeah, people say they want land, they want a ranch cuz it sounds so nice owning all that land and all, but I'm tellin' you it's a hard life if it's what you're countin' on for your livelihood. But I wouldn't give it up for nothin'.

Sure, I could sell my land right now prob'ly to some Houston attorney for a million-five. So what. What would I do then? Invest the money? And where would I go? I never known anything but this land and this life. I want to keep it in the family like it already has been for a hunnerd 'n fifty years. So my son and I are talkin' about the prospects of openin' up the ranch to special groups. We don't have any choice if we want to keep the place.

Ranching doesn't pay these days. It's happenin' all over. There's folks that're allowing mountain bikes to come on their land. That's one thing I don't care to look at. But there's some other possibilities.

Yeah, ranchin' is smaller now. Used to when I grew up, why, we had little ol' bobtail trucks and sideboards on our pickups and that's the way we hauled our stuff to town. Now they got these big ol' thirty-two-inch doolies [dual rear tires] with goosenecks and all that.

And it's a different ballgame. In those days they didn't feed cake or anything and now they got all these cakes, all these minerals, all this stuff, which is real good. And used to we'd drive cattle to Brady to sell 'em, to get 'em on the railroad, or haul 'em up there in little ol' trucks. And now we have an auction ring here, you know, that once a week you can take your cattle or your calves or whatever. It's a difference, yes ma'am. In that respect, why, it's lots easier. [BULL #11, MASON, p. 113]

Used to they didn't have any a this coastal Bermuda grass and all these grasses, and now the Soil Conservation's got us to plantin' and showin' us that if we'd keep grass on the land that the land wouldn't wash off and stuff like that.

Used to they had rock pens, rock fences, and now they got oilfield-pipe fences and all that. It's a different ballgame than it was way back then.

'Course the drought is not as bad because we have all this good feed. And they're makin' round bales and hay and stuff like that. Where, used to burn pear. I burned pear ever since I been a little ol' sixteen-year-old boy. You see these prickly pear here. Well, we burn the stickers off of 'em when there's a drought and then the cows can eat 'em. It don't fatten 'em but it keeps 'em alive, yeah. Everybody did that for years here. That's one way they kept their stuff a-goin'.

Oh, it's lots easier than it used to be, yes ma'am. It eliminated a lotta horses. And now, ninety percent of the horses are found around cities and ten percent are on ranches. And now people have four-wheelers and smaller pastures, and cake and pickups, and blow their horn and here they come. So it's a different ballgame than it was way back when we had to ride everday.

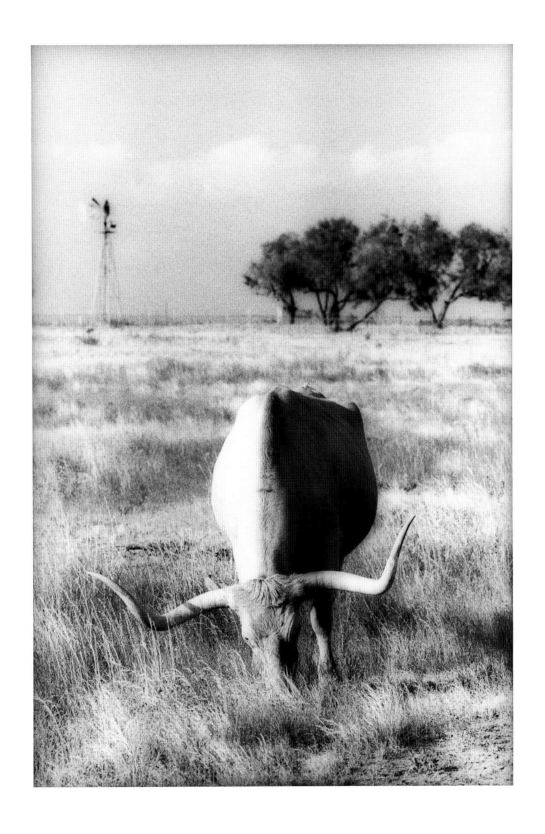

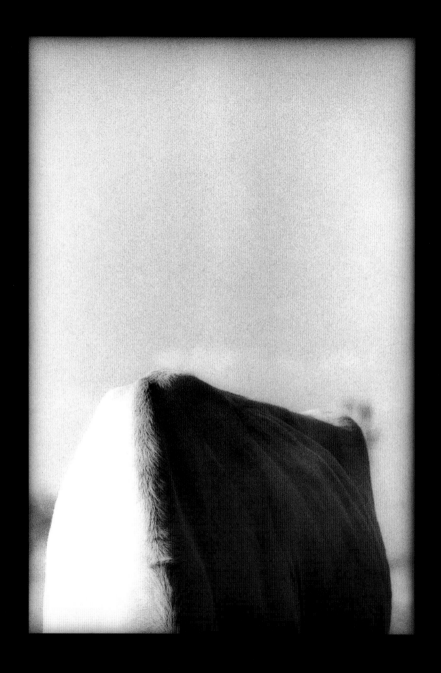

Now we stay at the feed stores. Used to you'd go in on Saturday and learn everthing, and now there's ranchers there everday at the feed store. It changed the ballgame.

And Longhorns, they came back. Aren't they purty cattle? Longhorns—I've got a few. They don't put as much tala [tallow] in their meat and it's not as fatty as other meat. They sell a lotta lean meat to these people who don't want the fat.

[STEER #10, ART, p. 33]

Yeah, they're a really popular breed now, the Sharlay [Charolais] are. They're real meaty but they like to cross 'em with other cattle. Because they were brought over here more for MacDonald's and stuff like that. You know, for grinding meat that's not quite as fatty as others. This kinda cattle was started over in France. And long time ago they used them to plow with. Put a yoke on 'em in the old days. They're real strong cattle. I got one little bull and two big bulls of Sharlay blood, yes ma'am. They're white. They're purty.

[STEER #1 AND #2, CASTELL, p. 126–127]

That's all the waste, yeah. All the waste. Skin. Long time ago you could butcher a calf or a cow and when you'd take it to the meat market, why, they would do it for the hide and the liver and the heart and the brains. Nowadays they don't even use the hide anymore. You know, like for shoes. Since rubber came out and plastic came out, why, the hides are not worth as much nowadays. Very little. Used to they salted 'em down—down there at town. You could take a hide down there and they paid you so much a pound for it when leather was real popular. Leather is *very* expensive now because they don't use it as much.

[BULLS #1, ROUND MOUNTAIN, p. 86]

Those are what they call Brangus. Real purty. He travels all over to get these pictures, dudn't he? They're lookin' at each other. They don't have to fight. They don't have any cows around. This is a bull pasture. Some people will leave the bulls out and then want all their calves to come at a certain time, see. And then if you have a bull pasture like this—in the old days, they wanted 'em in October, November, December—they would turn the bulls out and the cows that didn't breed, why, they just didn't breed. They'd wait till the next year. I just leave my bulls out. It dudn't make me any difference because I've got an auction ring here. I can take 'em anytime and sell 'em, see.
In the old days, when we hauled 'em to Brady to the stockyards and the trains, why, they'd sell 'em in June and July and they wanted the calves to be born in October, November, December so they could get 'em to market, yes ma'am. And that was a different ballgame in those days. Now we can take 'em to auction anytime we want to.

I couldn't tell ya what that is. That's the back a somethin'. Oh, it's the hump. See, the Braymer's [Brahma] the only breed that has a hump. In India, you know, they worship those cows over there. They won't shoot 'em or anything else. I don't know why those people over there are so crazy. You know, there's people dyin' and everything else and they won't feed any. And that's India. They're sacred. I don't know why. Whether Mohammed or who. Do you know?

[BULL #8, MARFA, p. 22]

That's cute. I like that. She's rubbin' the lice off her. Yeah, I like pictures like this. They get a lotta what you call horn flies, and sometimes you can look at 'em and they look like there's four million of 'em right above a bull. Makes bulls irritated. They're little bloodsuckers is what they are.

[COW #3, MASON, p. 125]

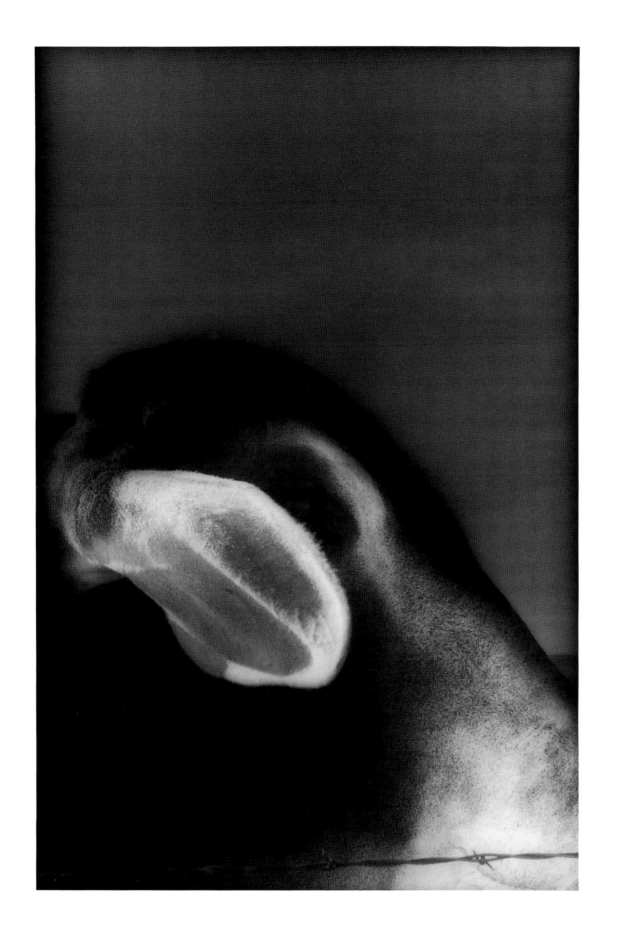

I don't like brands. I mean, a lotta people do. Well, to me, some of 'em don't turn out good. They'll get flaky like that on a brand. And-a-course, I'm sure it hurts 'em when you first brand 'em. Used to, you branded everything. A hot iron, yes ma'am. I just mark their ears. Well, if it's out on the end, it's called a swallowfork either to the left or the right. They just make a little V. And then underbit is under their ear. You make a little V under their ear. And overbit is up on top. If you want a swallowfork to the left and an underbit to the right, well you could mark it here and mark it here. You cut it with a knife, make a little V like that. But it goes into the ear and you can identify your cattle. Then there's a crop and a slope, and there's all different kinds-a-earmarks. Crop is where they just cut the end of the ear off. Crop to the left. Crop to the right. It hurts but it dudn't hurt long. It's just like castratin' where you make 'em from bulls to steers, why, it's best to do when it's young. This brand is comin' off. It's peelin', see. Usually they put a salve or oil or somethin' else on the brand and it helps it peel. It dries and then it peels.

[COW #23, MASON, p. 102] In Texas, you can do anything you want to. You can brand 'em any way—earmark 'em any way. Like those marks stapled to the ear. If I have fifty cows and I want 'em from one to fifty, I put a tag in their ear. Well then, when they have a calf, say number 25 had a calf, if it's the first calf I can put number 1 on the first calf so ya know that 25 Cow—oh, that's a lotta bookkeeping. I'm not a bookkeeper. I'm not gonna do it. But a lot of 'em do it. See, they'll put the number of the calf and then they can tell if that cow gives a lotta milk or if she dudn't give milk. If she dudn't breed one year they can have it in their book and they'll get rid of her. It's a way of marking.

Huge. They make 'em big nowadays. For awhile these stock shows in San Antonio or Houston, people [COW #3, LLANO, p. 32] wanted real big cattle. Long time ago they wanted a calf to fatten out around a thousand pounds. And now they want 'em fourteen-hunnerd to sixteen-hunnerd pound. Now they've gone back down to about a thousand-two hunnerd. They change it all the time so people'll change their bulls. Well, it's supply and demand. For awhile, we sold to MacDonald's and Taco Bells. And The Outback and baby-back ribs for Chilis.

They're the highest-price selling cattle, is the crossbred. Makes better beef. They claim the [COW & CALF #18, MASON, p. 80] first cross—I think they call it hybrid vigor where you put together two different strains of breed—that first calf'll grow better and does better. And then you can breed that back to a crossbred or a Black Baldy is what I hear, or what I read, anyway. I can't believe all I read but I can believe some of it. Experience is the best teacher for me.

Now these photos, can you tell me what's the difference between makin' 'em look real and [BULLS #15, MASON, p. 26] makin' 'em look like this? Why is the reason? It looks like it's a little blurred. He must like it like that. 'Course some of us like it like that and some of us see it in a different way, I guess. Dif'rent strokes for dif'rent folks.

[BULL #25, MASON, p. 143] You tell him this is the kind-a-picture I like. No details.

They go from looking mean to looking ghostly. I like that, though. Because they *are* mean. They can be. They're very temperamental animals. These look like a Braymer [Brahma] cross. You can tell by the jowls, the ears. Looks like there's maybe some Simmental in it. Just because they're so white with the dark eyes. [STEER #17, CASTELL, p.132]

I like the way that everything has texture. Even just the changes in light and dark have a texture. I like the way that it's whatcha you normally see but not how you normally see it. And this one particularly where you've got a lot more curiosity from them than you normally get. Normally you get what I call the *Bucolic Bluebell Advertisement Cow*. That's the way people think cows look. And these don't. They look very natural and very rugged. And they look like they're upholstered.

What I still can't figure out though is how he gets the crisp—I mean, his technique amazes me because he has crisp detail but it is very muchly everything else. It's kind of like understanding a computer. I know how they work. But I don't understand it. Same with his photography. I know how he did it. But I don't know how he did it.

[STEER #14, CASTELL, p.52] This is like the corporate quarterly report, *Portrait of the Cow*. Including the flies. And assorted debris. Sixteen never looked so good. In the best vein, I compare this work to Robert Mapplethorpe. Because some of his studies he would put a black and a white together in the same picture. And that's what I see a lot of, is that same contrast and tone and shade and dark. And that's what I like about even this one. You've got both of them.

He's gone way beyond makin' 'em look like animals though. This looks like something that's been staged—as far as set-up—because they don't look like animals anymore. Particularly these guys. In fact, I think I saw these guys sitting in front of the feed store earlier. The character that came through in the faces is incredible. And this one, though, because he's not white—he looks like he's floating behind—dudn't look like he belongs. [STEERS #19, CASTELL, p.87]

One of the things that I find very interesting about these photographs is the fact that you see the obvious. You find that. And sometimes it takes a minute to find that. Once you find the obvious, you start finding other things. And like with this, with just the way that the hair goes and the way that it lays, which is beautiful by itself, but looks like it has human hair. I understand the word "cowlicks" now. And I envy the hair—as one who's losing it. [BULL #22, MASON, p.68]

I'm bowled over by how he gets some of these. Because I know what it's like to try to photograph a cow. Either they won't get out of your face or they won't come near you. And he does a good job of getting just the right amount of aloof interest.

[STEER #12, CASTELL, p.47] Oooh. Oh, man. This one's incredible. I like it because the eyes. It's almost mournful. He seems sad. But beautiful lines. It looks more like a sculpture than a photo. This isn't the same animal as before. Well, I'll be darned—same animal but totally different aspect of him. Because in the earlier one, where he almost looks young and playful, here he looks old and almost worn down. That is a gorgeous picture.

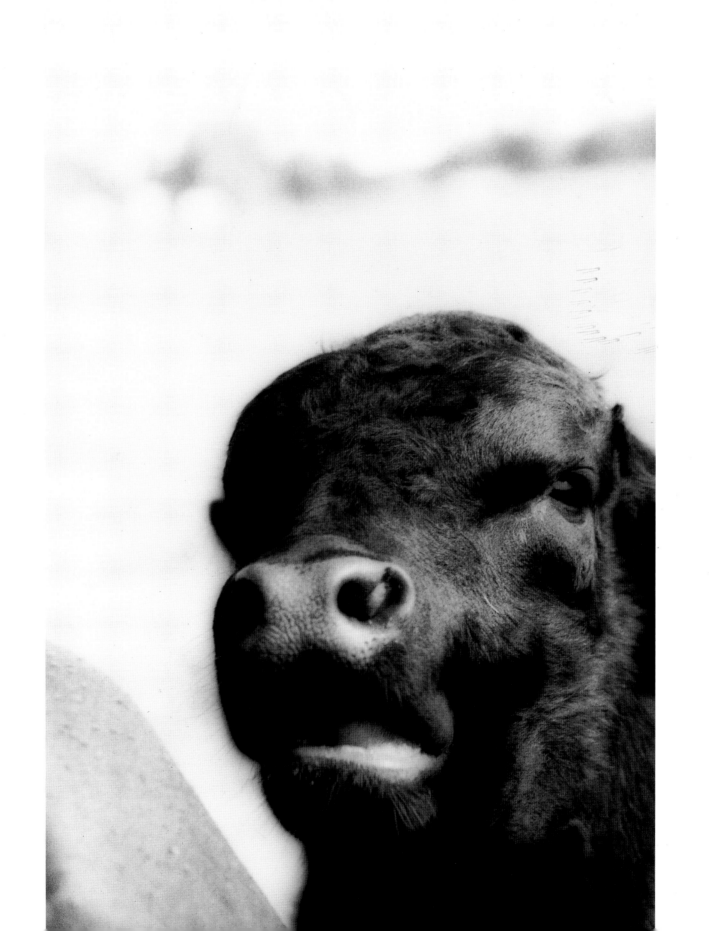

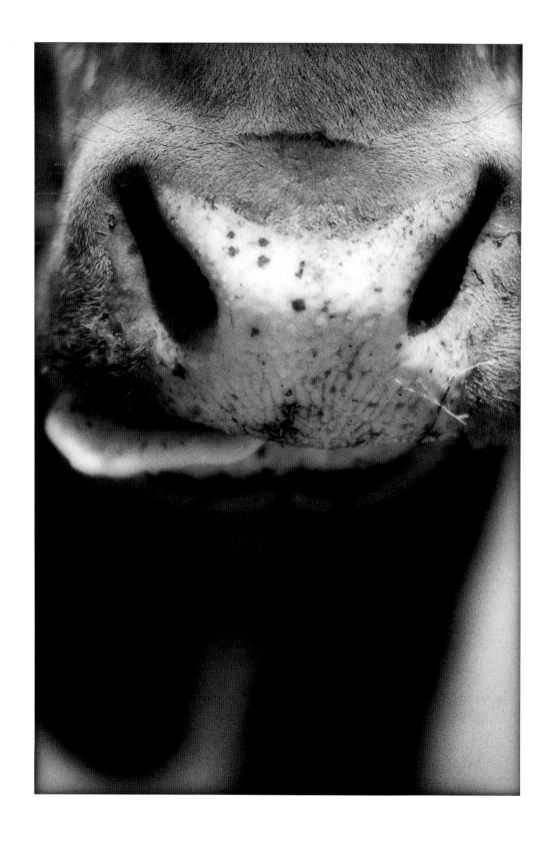

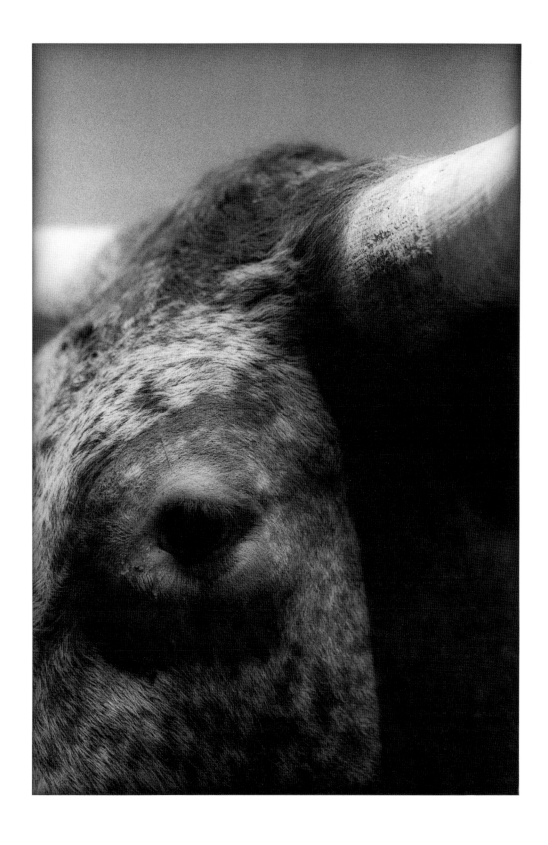

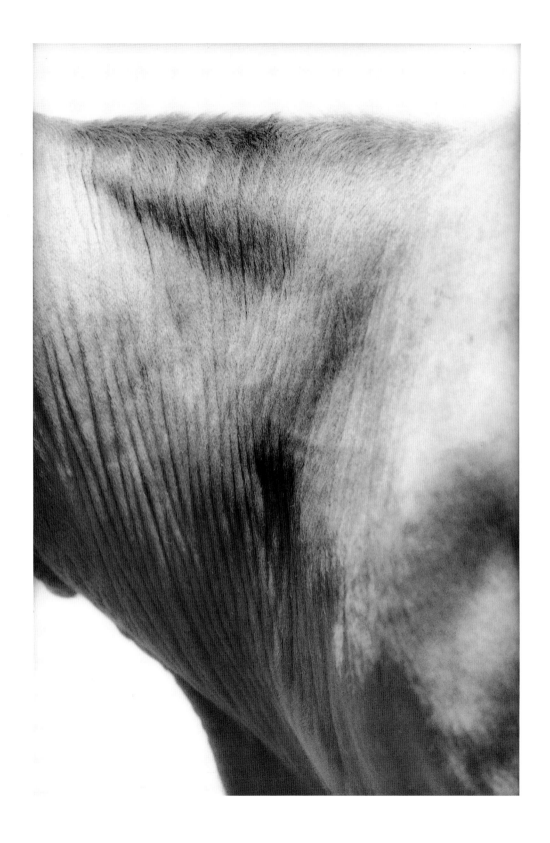

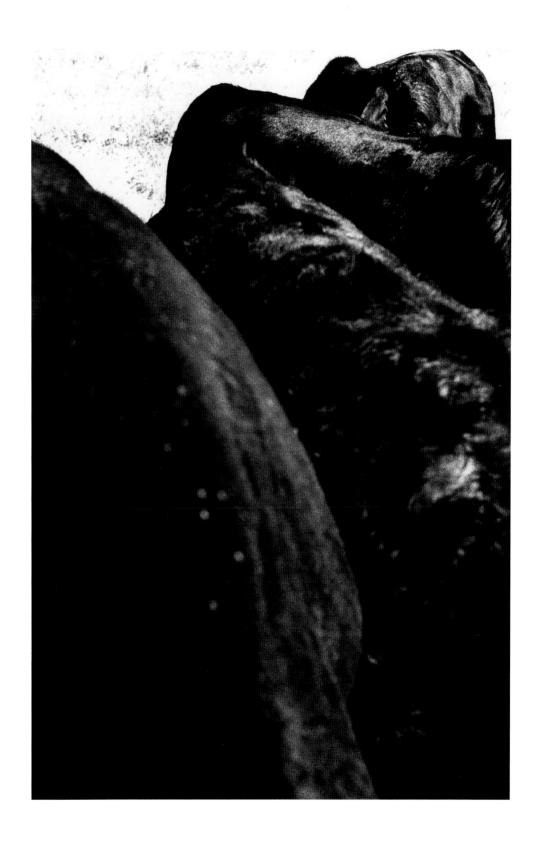

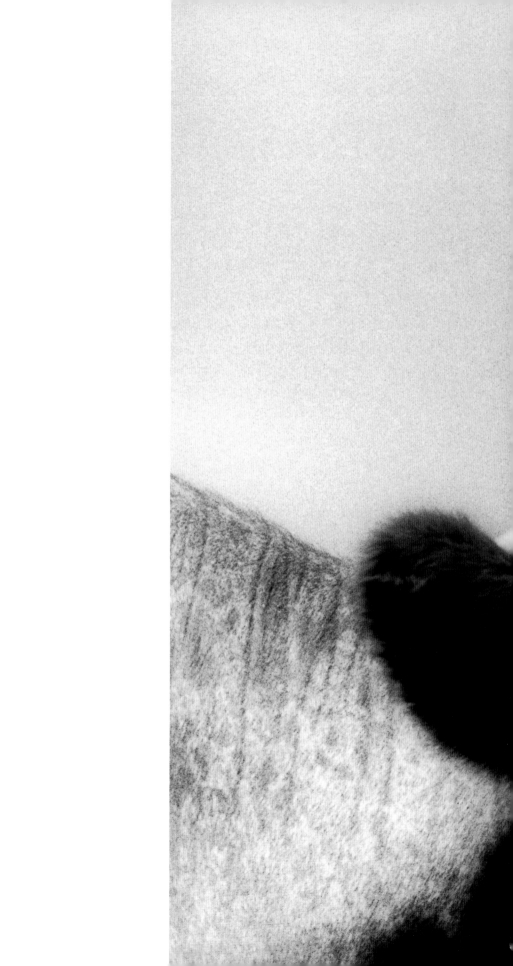

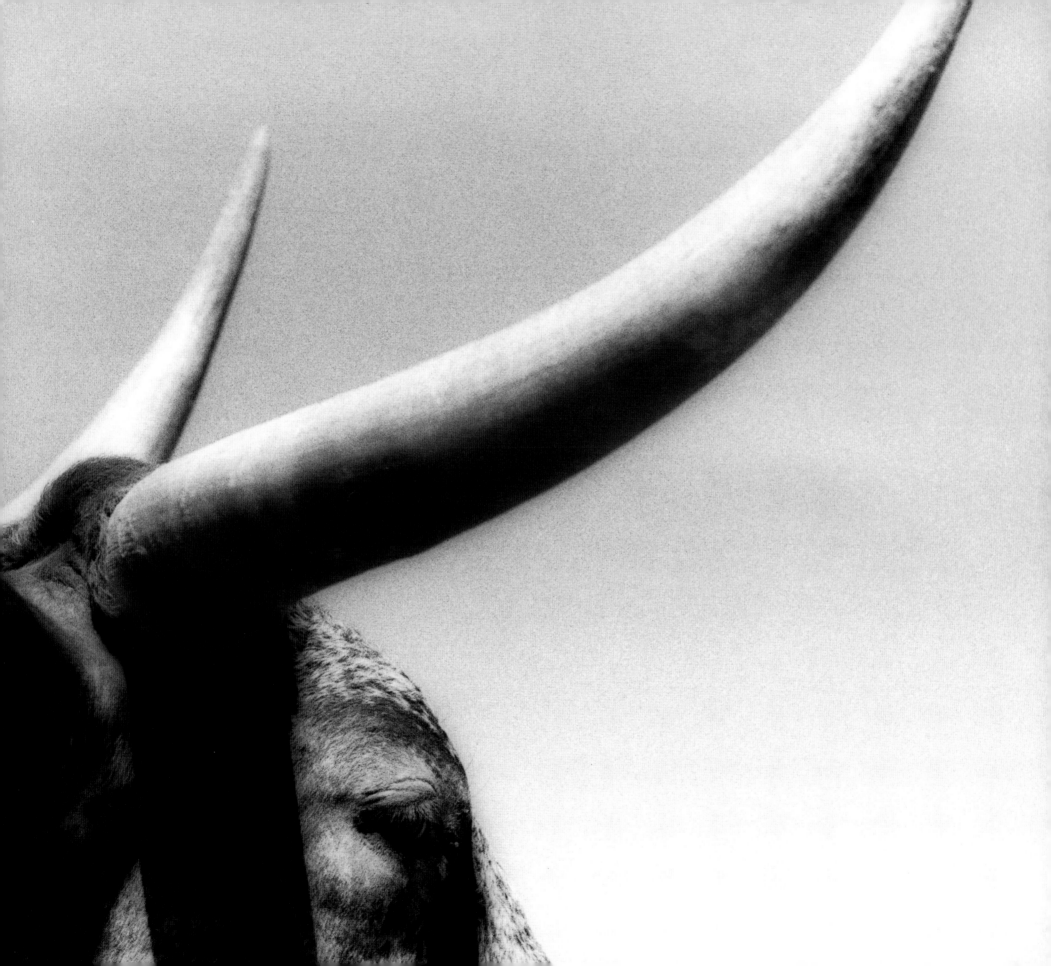

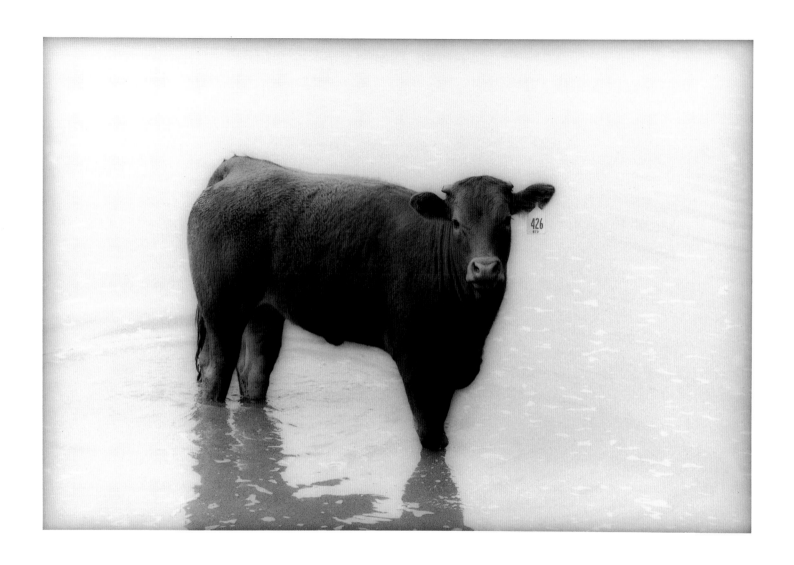

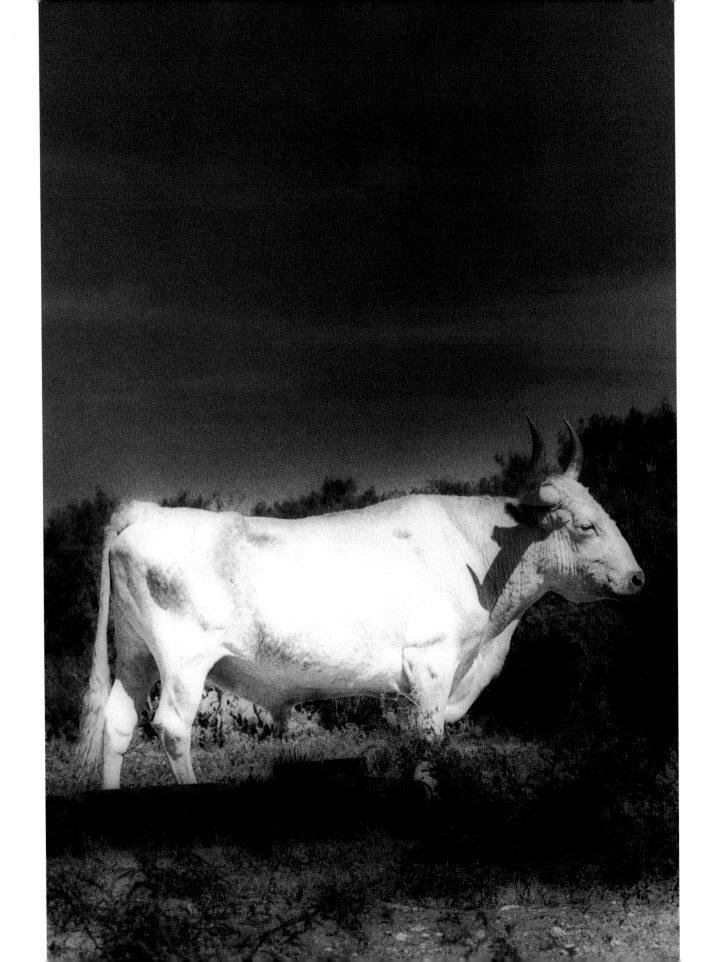

I'd accuse Burt of painting with light and shadow and tone. That's what he does. And it's classic portraiture. Not photographic portraiture but classic painted portraiture where you can then manipulate shadow and tone and all that to get the effect. And he does the same thing with photography which is hard to do. Because light doesn't cooperate. But he has a way of making it do that.

[STEER #13, CASTELL, p. 47]

I like this one because he uses opposites and the opposites are what attracted me to his photography. The background would either be very light and your subject is very dark OR the background would be very dark and the subject is very light. And that's part of that Obvious and then the Non-Obvious I was talkin' about because the difference in the dark and light makes you look at something. But then all of a sudden you move onto another area of it and you start finding things in it.

[BULLS #1, ROUND MOUNTAIN, p. 86]

I like the carpet. It's a nice hide. The animal disappears and it becomes something else. In this case, a very nice piece of leather. I know, it's awful. But I grew up on a farm and ranch. So I look at 'em and see them for what their potential could be. That's a beautiful hide. My friends in Austin would have *my* hide for saying that. But that's a beautiful, beautiful bull skin.

[BULL #3, ROUND MOUNTAIN, p. 77]

I love big overstuffed club chairs. He looks like he's already a big overstuffed club chair because at this point when they're standing there, they are the laziest animals in the world. Why? Because they really do nothing more than eat. And breed. So he stands and walks around and he's already got the whole appearance of being a sofa or a club chair. It's easy to see why people decide "Ooh, leather could be good. They look comfy."

What's funny is I was raised around cattle and I've never noticed—partly because I try to stay away from the head and the rear—if I'm working with the head we've usually got it clamped down and you're notchin' ears, you're doing something to them—you don't stop and look at the animal. So part of the reason I enjoy his photos is because you actually look at the animals that you've ignored for so long.

The position of the ear you couldn't of asked for. And you're not quite sure which way to look at it until you find the bob [barb] wire. And you follow the bob wire, and then you sorta realize that you're missing part of him down here. You don't have enough to go ahead and visualize the jaw and all that. So you've got from about the middle of the nose up to the top of the head. There's just something about the black, the white, that is gorgeous.

[BULL #6, MARFA, p. 93]

With these photographs, you're starting out and you're looking at the animal as a whole. And suddenly you move in close. And he takes it to its logical conclusion which is you go from out here all the way up to see what changes—and what's different. And can you still tell what it is?

It looks like a geisha with her fan, hiding herself. I've dealt with these animals. There's noooo personality trait the same as a geisha, except for that ear. Not at all—though the Kabuki makeup's the same. To me, his work takes what you know but in a way that you don't know. I had somebody comment to me about some of his photographs, "Well, he got a little too close on one of those." And I thought, "Well, no. Actually, that was the point."

Now on ones like these he uses the whole range. And it's a way to kind of lead you in because sometimes you may not be able to make the leap on your own. So he does a little hand-holding. And pushing.

[BULL #1, MARFA, p. 131]

Ah! Now this I love! You lose all the detail. You don't see the iris. You don't see the pupil. You see that dark eye. And if you've ever had to deal with cattle, that's all you really see. Because you take away the personality. You can't have a personality of something you are going to…kill. I mean, that's a commodity, not a pet. You can't think of it as a pet. What's funny is the eye almost looks sympathetic here. Normally that's not the way you see it. But here it looks sympathetic and it actually looks like it has intelligence which is bizarre since these animals have very small intellect. They're very good at finding their feed and going to it—with help. And that's about it.

[STEER #3, CASTELL, p. 83]

[STEER #4, CASTELL, p. 119]

Orchids! That's what it looks like. It has the same look and feel as orchids because the same way the orchids turn up. Again, this equals the work of Mapplethorpe's—people only think of one thing with Mapplethorpe—but he had such a broad oeuvre that covered everything, and his flowers and still lifes, and even his nudes were incredible. I know! Simmental orchids! Very rare. Hard to find.

I like the tires. The tires are a great touch. Actually that is an incredible pose. Now there's something I don't normally see in Burton's pictures, I just realized. You never see a distinct shadow. And that one has a distinct shadow. Normally the shadows blend in and go as part of the tone. And this one has a distinct shadow of the head particularly—which, considering that's the most prominent part of him. I like the tires too. People've got the tires out there to control erosion. They use 'em to put salt in. They serve a purpose. They're not pretty but they serve a purpose.

[STEER #1, BLUE MOUNTAIN, p. 105]

[BULL #1, HIGH PLAINS, p. 72]

This is my number one favorite. Part of it is the fact that he is so alone. Obviously he's at the corner of a pasture. You've got fence in front of you and fence running off in the distance. But there's nothing else in the pasture as far as you can tell. And he's backed up in the corner. It's weird because he looks so alone but yet so contented with being alone.

I like it also because that area of the state—to me it perfectly captures that the horizon and sky are all one thing. And up there it is. On a hot summer day the sky disappears and it just goes forever. That, and the fact I love fence. Strangely enough—having built more fence then I ever care to remember—the fence is one of my favorite parts of this picture. The fence goes on forever. And here he is defending this territory that he's got one corner of. And as far as he's concerned he rules it all.

Lumps of clay. That's what this is. Bulls have one purpose in life. To reproduce. They are the most stupid and instinct-driven animals, purely. Purely on instinct and hormones. And these two guys—I think of the cliché of muscle-headed football players, which is not true, being a muscle-headed football player. But that's what they look like. The guys who're standing around. They're basically S & M—stand-and-model. They're posing. You know, looking good. "Look at that heifer over there. Looking good."

[BULLS #2, LLANO, p. 134]

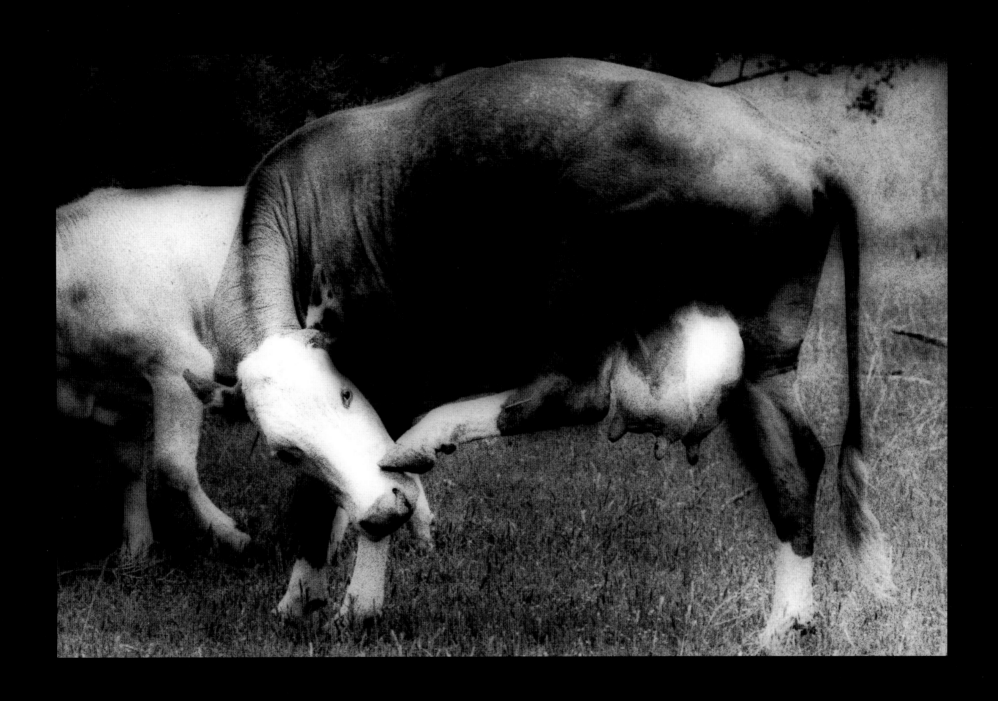

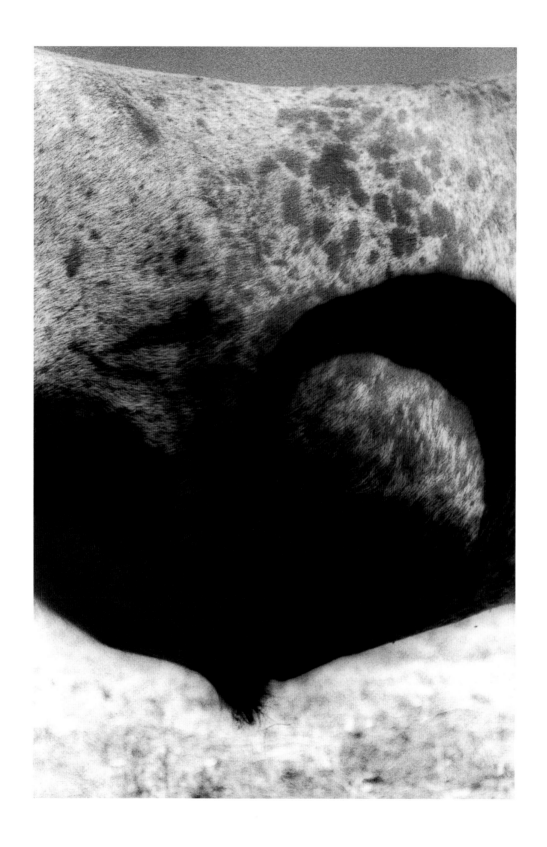

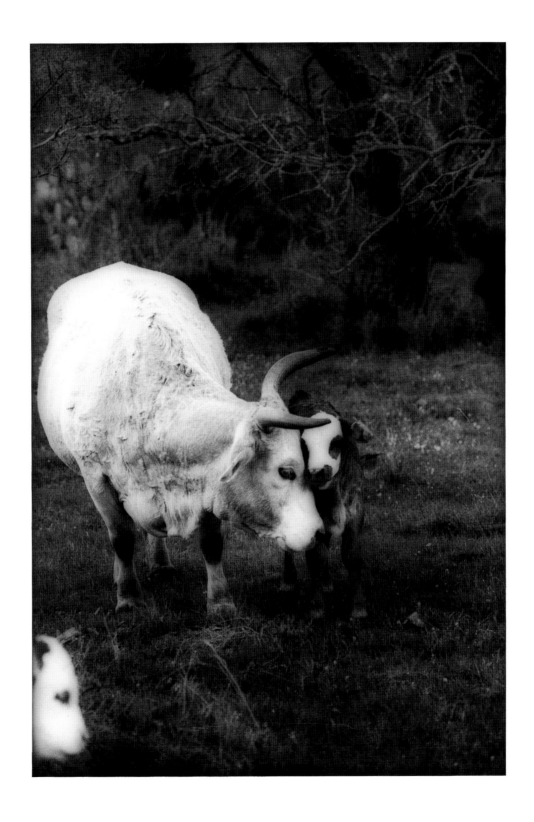

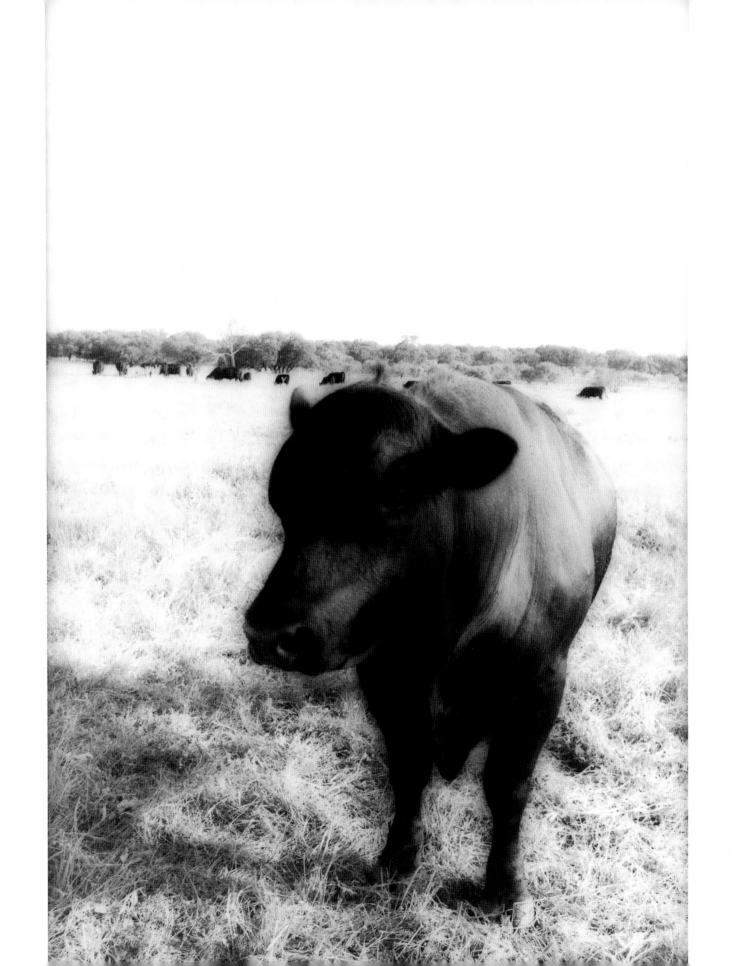

You tell him this is the

kind-a-picture I like.
No details.

And I love it because it's just like the same thing that you see with the guys that are muscleheads that stand around. You sorta look at 'em and go, "You are nothing but a lump of clay. A good-lookin' lump of clay. But a lump of clay." And these guys have not a thought in their head. They're absolutely gorgeous. But they're gorgeous lumps of clay.

These guys are idiots. Again, I'm not relating with animals because, having grown up with them, you no longer do the deal of giving them personality because you don't want to give personality to something you aren't going to keep. But you can't help it.

[STEER #1, BLUE MOUNTAIN, p. 105] This is one that has a sculptural quality to it. Just with the white and with the shape and everything else, it looks like it's a statue standing out there. This poor guy looks like he's got some age on him. The amount of wrinkles and just like how people tend to get age spots, animals do too. And he looks like he's been out there awhile. And again, it's the white skin. They show it faster. That's the leather that you get that has character. So… he's got a lot of character.

[STEER #4, ART, p. 99] This one pretty well hooked me because it's all the elements I need to identify what it is, what orientation it should be, I know what's up, what's down, and yet if I cut out any one element, it's tough to identify anymore. And I like that. I like something that challenges me to look at and figure out, "Am I looking at it correctly? Is there something I'm missing?" And, all I have to do is mask out part of it. If I take out the horns, now I'm not sure if I've got the eye in the right orientation. If I take out the eye, I wonder if I'm looking at the horn right or maybe that's not a horizontal horn, maybe it goes up, and I need to look at it differently. And it has the most incredible tone.

Obviously that's a horn over his shoulder. But where is it coming from? Is it his horn? If it's not his horn, what's over there? Jackson Pollock did a series, and I think there's only five in the series, and it's called *Night*. I think it was more an experiment to find out how black and non-reflective you can make something. But it's fun. The whole point is "How dark is it?" The part you normally would think of as black is now considered the light part. It makes you look at it differently. [STEER #6, ART, p. 41]

This reminds me of that. I mean, you've got one distinct area of light up here besides the horn. And the horns are the light part. Everything else just disappears. And there is no detail. I know where everything is. I know the neck. I know the head. I know the ear. But other than that, black on black.

If you're looking at just the shoulder and the back, this looks like the Mariner pictures of Mars. You've got this whole foreign surface, this whirlaway crater. And the horn is the only part that brings it back. It's got a very alien surface. And it looks like some of the great shots of the surface of the moon. Especially if you take out just the horn and you look at it—"and now we have proof of non-intelligent life on Mars." I mean, it looks like cloud formations and the water.

And then the rancher in me comes out. "Boy, it's a beautiful hide." What's interesting is knowing, in color, that hide is not going to be as pretty. See because, color variations can be what make or break when you're buying leather. You know, it's too much of a color variation or not enough of a color variation. This one has an absolutely gorgeous hide.

But I'll bet you, because I can see the differences in color and tone in black-and-white, that it [STEER #7, ART, p. 40] wouldn't be that pretty in color. Which sometimes you have to take away all that detail to see what's really pretty. Since the more detail you have, the less attractive something is. It's kind of like most of my relationships. The further into them you get, the less attractive they become.

- -

My dad had ranches and we were always around 'em. It's been home to us all these many years. Ranching is not a good way to get rich. It's a wonderful life really, to live out here in the open. The ranchers have a hard time now. Nobody in the world could buy ranchland and ranch it and ever pay for it. Cuz the ranches are being sold and broken up. They're subdivided. Not many big ones left anymore.

I s'pose you could make a livin' on a ranch if you had enough land, and had it paid for, and didn't have a bunch of debts. But you wouldn't live very high on the hog. Unless you had a great big one. There're very few large, really large, ranches left.

Most of 'em have their land cuz it's been passed down. It's at the point now to where you can't even inherit land and keep it because the death taxes are so high. They're goin' to change it but it hadn't been changed yet.

[STEER #1, CASTELL, p. 126] That's the dewlap. The skin under the neck's called the dewlap. I'm surprised this cow's still livin' cuzza that tornado that went through there. Oh yeah, it wiped out a bunch-a-cattle. They reported that cows were in trees—and skinned—and eyes were sucked out. It was terrifying the night that thing happened. We were out at the ranch. We were havin' a round-up. They don't have 'em like that here very often but this was a Category Five tornado.

Where it went through down here is just about a mile on the other side of the river. About halfway you'll see the area. Over to the right, there was an old, old ranch house there that I'm sure was well over a hunnerd years. And you know, for years we've been seein' that house and after that tornado came by, there was not even a rock left of the foundation. Took all the bark off all-a-the mesquite trees. And there was maybe a hunnerd head-a-cattle that were lost.

[STEER #4, CASTELL, p. 119] This is good how he faded all the rest out except just that dark nose. That's good. Well, this one's been fed very well. Doesn't have any prickly pear in its face. They eat anything. Especially when it's dry and they find anything that's green. Oh gosh, they walk around with their tongue hangin' out, all full of thorns.

These look like Brangus. It's a recognized breed now. It's three-eighths Braymer [Brahma] and five-eighths Angus, Black Angus. They're nice, good cattle. A little bit more gentler than the Limmazine [Limousin]. Everybody's goin' with black cows now. You can look at the ground and tell what time of the year these were taken. Look there. See that? Looks like that was taken probably during the drought. There's not much grass. Nothin' on the ground. And all the mesquites don't have any leaves on 'em.

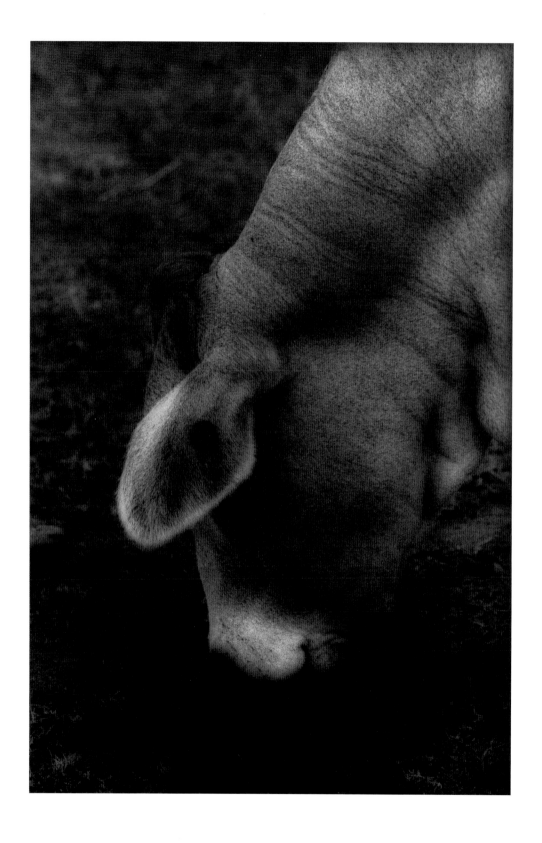

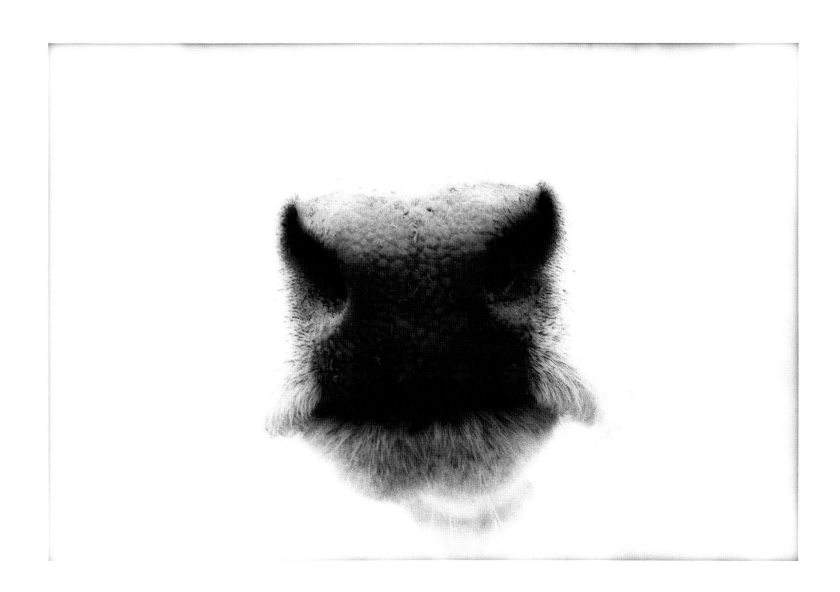

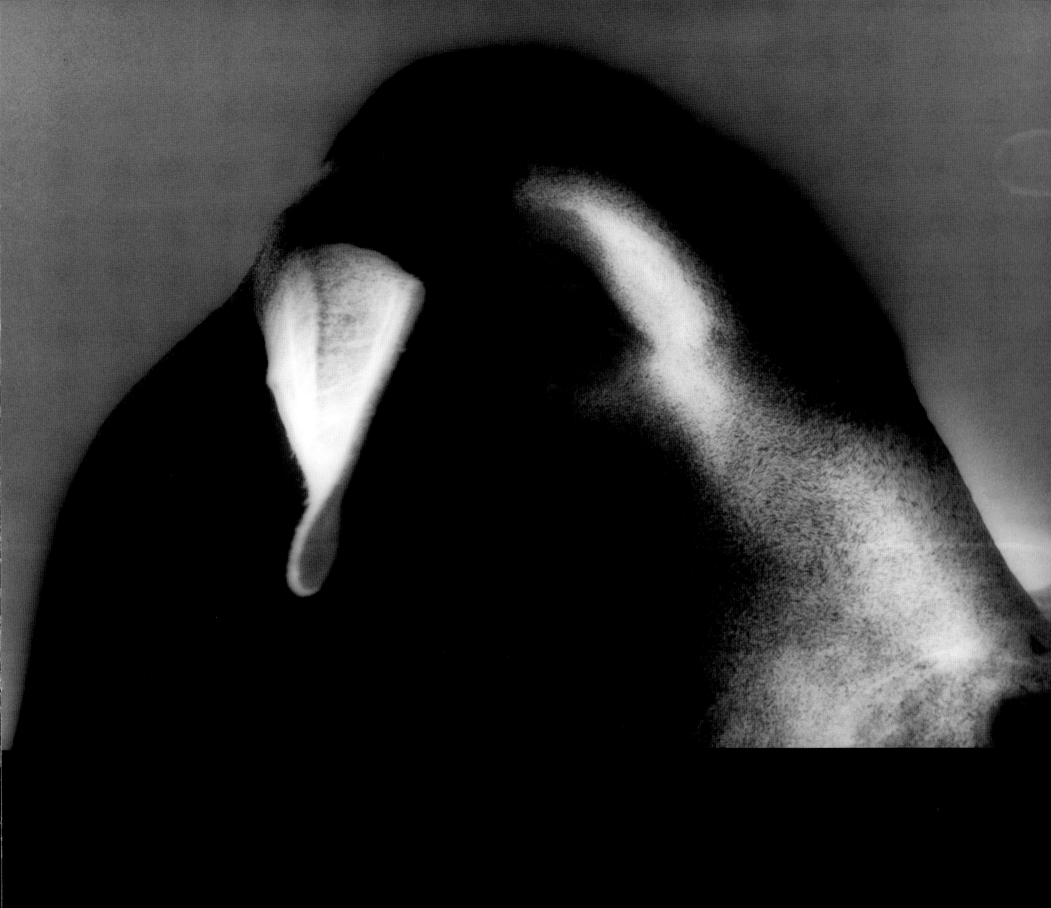

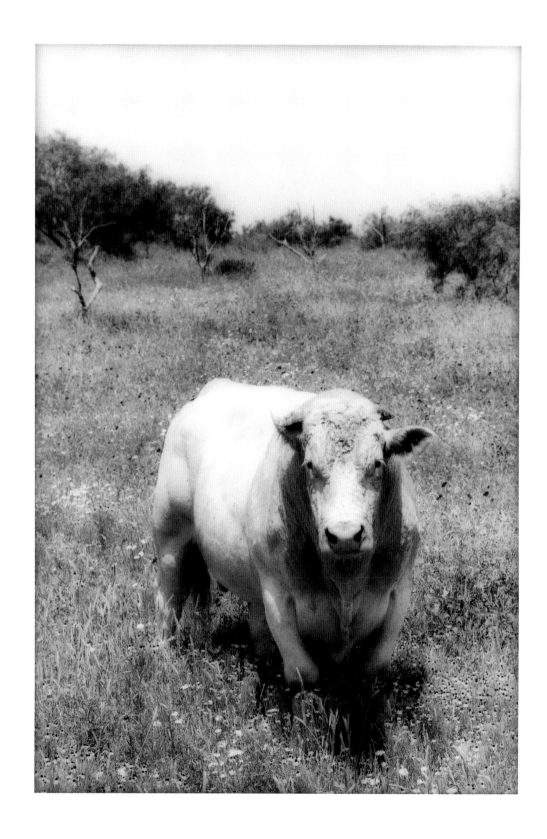

I guess maybe you would say we're on the edge-a-the desert because when we have rains the country rebounds very fast. In a big hurry. You can look out there and right now there's not a square inch where isn't sumpin' growin'. And in a drought year, it's like I said so many times, there's nothin' for the cattle except rocks to suck on. That's all they got. Everything they eat you have to give it to 'em out of a sack. Or sell 'em. One or the other.

But now it's just a Garden of Eden. It's really beautiful here. My place here is just small. I just have a couple hunnerd acres here. Right now, I don't even have any cattle here. I'm gonna bring some down from the ranch.

But I'm a pretty typical example of what's happening to the ranch country. I have two children. My daughter is now a widow and she's got other interests. My son is in the city. And he hardly even comes up any more for the round-ups. He's just busy all the time. And neither one of 'em had children so that takes care of that. The generation stops here.

And I'm eighty-two years old, so there's no way for me to keep it myself. That's right. Eighty-two. What we have out there is about three sections—about two thousand acres. We've had so many people look at it. And they want to take it, subdivide it, cut it up which I don't want to put up with and I'm not going to. But it's just the way things are goin' now. This place I have now is all I need. I live here to be away. I don't have close neighbors.

[BULL #5, MARFA, p. 141] I think that that hump is a reserve of fat for hard times. I love to be around cattle. Well, I just love all animals. I've always loved to be around 'em. I grew up around 'em, you know.

We have round-ups and the vet comes out with some help and keeps records on all the stock, so that's the easy way to do it. And we usually have our round-ups to coincide with times that we want to sell stock—calves and yearlings and things—and take them to market. 'Course there's a lotta pen work that you have to do. Cuttin' the cattle up. Separating the cows and the calves. And the calves that need to be worked—need branding and castrating and all that stuff. And pregnancy testing of the heifers to get a feel how old the calf is in the inside. That's what our vet does. Takes a long plastic glove and runs it through there and then checks the fetus in there—how old it is.

When I was a kid growing up we had problems ranching you don't have now. For example, they had the screw worm problem. They eradicated that. That was all over this country and, you know, all of your ranching activities at that time, before they eradicated those awful things, worked around that.

See, after you've had a freeze the screw worm flies are dead and they don't infect the sores, and raw places, and the brands and all that. So then you usually worked your cattle after the first frost in October, November, see. And then you always wanna be through with all that before you worked them in the spring. Because of that brand, you brand 'em and turn 'em loose and believe me, a hunnerd percent of 'em would get infected with screw worms. The fly comes along and any open wound—and this is also true for little baby stock—when a little animal is born in summer months, it has that damp wet navel attachment—they'll get screw worm in that. And they kill 'em.

The female fly lays the eggs right on the wound. They hatch there into little worms and those worms eat right into the flesh. That's another reason that we didn't have as big a deer population in those days as we have now. Because little deer fawns are all born in the spring like May and June. And those ol' flies'd get on 'em and a big percentage of 'em would die of the screw worm. How they eradicated them is an interesting story in itself.

See, the screw worms infected lands all the way from here down through Mexico, Central America, South America. So they discovered—this was pretty scientific work done on this—the female blowfly—blowfly they call 'em, they laid their blows on there, that's what they called the eggs—they discovered that she breeds only once in her lifetime. So they got to raising 'em in the laboratory and all the male flies they would use radiation on and sterilize them. Then they would take millions of these male flies that they had raised in the lab and sterilized. And they'd put 'em in little small cages—delicate little cages—and they'd go by in airplanes and drop 'em all over the country. And when it hit the ground, the cages'd fly open and those flies went out and since the female would only breed once, all these sterile flies were goin' out and breedin' the females and they didn't lay fertile eggs.

And they started on the southern part of the country. And they went right on through the country and they completely eradicated that. The program is still in effect because just on rare occasions somebody'll find one. Everybody watches closely. Believe me, the ranchers watch that. And if anybody finds an infected animal they go in and just saturate the whole countryside with those sterilized flies. Idn't that amazing? Instead of tryin' to kill it with chemicals. Or with a flyswatter. Now that would take a long time.

There's a lotta hardships to ranching. There really is. You got the droughts to go through. You got floods. Right now, I'm concerned because this year we have so much vegetation. There is a big, big crop of pea vine—that's a little plant that grows all over the country. It looks like a regular garden pea a whole lot. Has pretty little lavender-white flowers on it. When the cows eat too much-a-that—it don't affect a whole lotta your cattle usually, but in the last few years I've lost several head to it.

The cattle eat it and it infects their nerves. Unfortunately, there's nothin' you can do about it. You can't eradicate it because it's a wild plant and you can't do anything about it. You can't go and try to get it all. If you use poisons or chemicals, you'll kill everything. You don't wanna do that. And to pull it up, you'd be there forever and ever. I'm namin' that as just one. There are other noxious weeds too, a-course, that we all know about.

But I just had one of my bulls die from eatin' pea vine. And I paid two thousand dollars for him. He was gettin' kinda lethargic and one day I found him out in the pasture, just dead. So we dug a hole and buried him. Gosh, a big ol' twenty-five-hunnerd pound bull, it takes a big hole to bury him in.

And I had a little bunch of heifers down here I was weaning to keep for replacement cows. And we had a pretty good storm one night and I said to my wife the next day, "I haven't seen those heifers. Come get in the truck with me and we'll drive over and look."

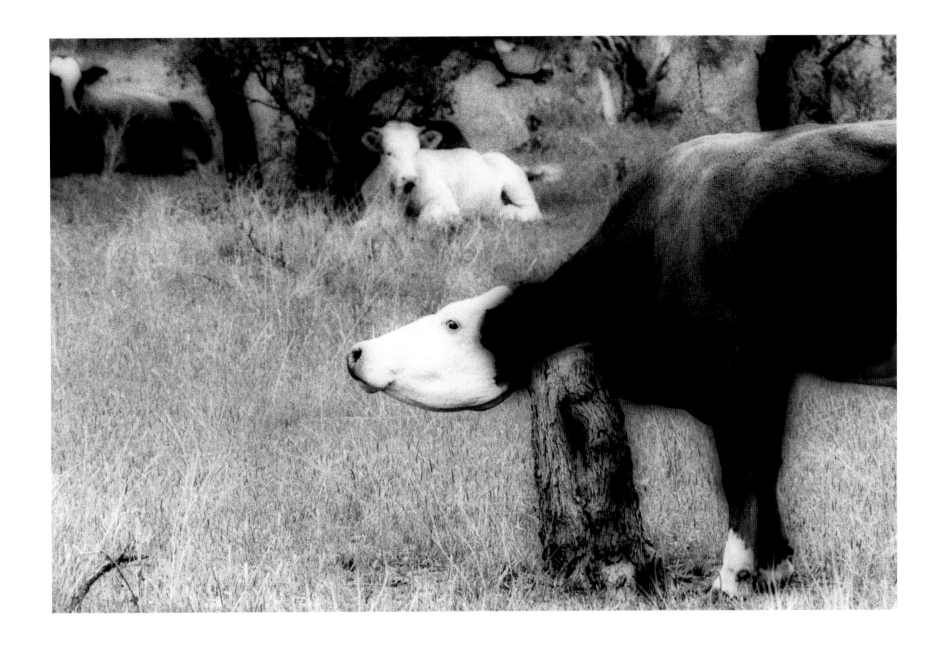

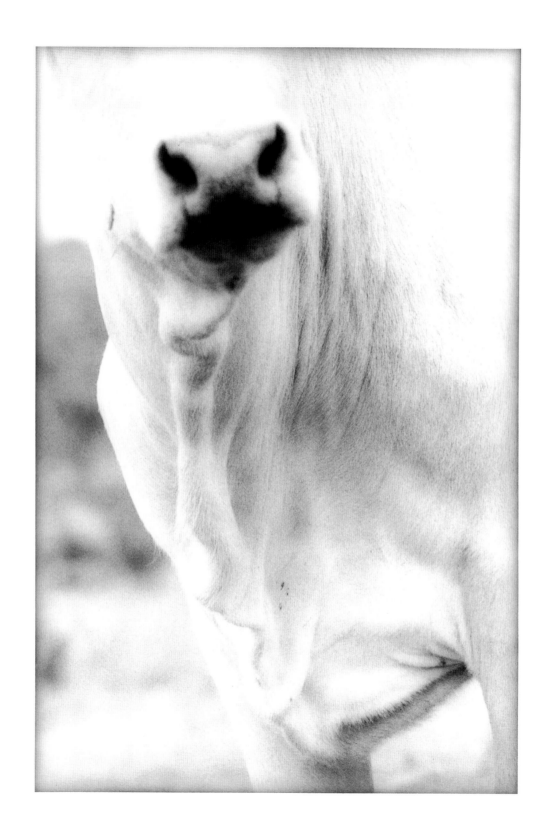

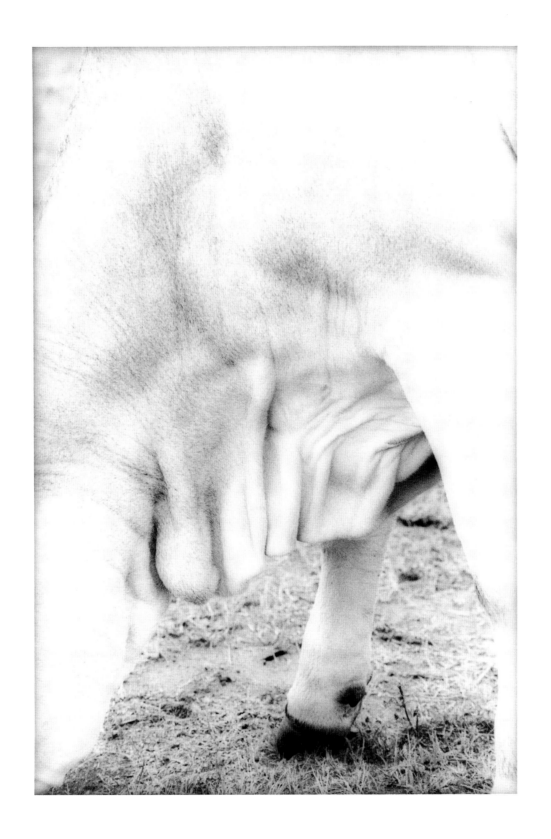

And by golly, I saw one heifer and she was not where she was s'posed to be. She was on the other side-a-the fence. And I said, "Let's go down there and look." We went down there and lightning had struck. Apparently it had hit that fence line. And five big ol' beautiful big fat heifers were layin' there dead in one pile. Apparently—during a storm they'll kinda bunch up sometimes—and I think they had backed up against that fence and maybe they were all touching.

'Course another thing that you always have to contend with, especially on larger ranches, is varmits—a baby calf or any baby animal is prey for a varmit. For wolves or coyotes. And I talk to some friends who have a place down the river from town there. The coyotes were so bad down there he finally got to the point where he only kept Brahma cows cuz they would fight the coyotes off better than the other breeds.

In this country, I guess probably the primary, foremost, and most numbers of any breeds were the Herefords they started with over here. First, in the early days, the stuff they brought over was that Spanish stuff. That was the background of your Longhorns. There weren't native cattle here, see. They were brought over from Europe. And the Spanish, of course, were the first people over here primarily and I guess they brought the forerunners of the Longhorns and the Mexican cattle they have. And then the Herefords. And that was the prevailing breed of beef cattle in this country for years. I 'member when I was a growin'-up-kid, there was a Red Durham cattle that were here for awhile. Then they started bringin' in some of the black cattle. They brought in the Black Angus. Then they did a lotta cross breeding. Then they got to infusing the Brahma blood with English breeds.

I take a lotta these cattle magazines. They're interesting. Oh, fifteen, twenty years ago I started using Limmazine [Limousin] bulls, a French breed. And my herd is mostly Limmazine now. They're good cattle. I like 'em. They're red cattle.

We raise our cattle for beef. We usually sell our calves when they're about six to eight months old or keep 'em until they're a little heavier. When the cows leave here, they usually go to the wheat fields. When the buyers buy 'em, they put 'em on the wheat fields and, on good years, they can put as much as three calves to an acre or more. They put fast gain on 'em that way. And then they put 'em in the feedlots. So that's the story of where most of ours end up.

Usually you sell a cow when she's about ten or eleven. A good cow will make a good mama cow past that. I've seen cows fourteen, fifteen years old still producin' good. But they start breakin' down. Sometimes they'll have bad teeth or somethin' like that. And then at that time they go to McDonald's—and the other places that use hamburger primarily.

Cows calf every year. A cow misses a year she goes to the slaughterhouse. The gestation period is nine months. And they usually have their first baby when they're two years old. 'Course you want 'em to breed early. Earlier they breed, the sooner you get a calf out of 'em. If they miss one year, if they miss one calf, see, that's a whole year gone to waste. Takes as much almost to feed a cow *without* a calf as it does to feed her *with* one.

Another thing that they discovered in the last few years—I bet you didn't know this—that the circumference of the bull's testicle affects the time that his daughters will come in heat the first time. Nowadays, when you go to a bull sale, they'll give you the circumference and the centimeters of the bull's testicles at a certain date. Because you want your heifers to come into heat as early a date as possible so you can get a calf out of 'em. So, the bigger around, the quicker. Now that took a lotta research to figure that out.

They love to scratch themselves. That's a neat picture where he got the picture of that cow right now. That's good. Well, you know photographers spend a lotta hours not gettin' anything. And then all at once they'll get somethin' that su'prises the heck out of 'em. It takes a good one to just see that. And be ready to snap it. Good picture. [COW #3, MASON, p. 125]

We call them Black Baldies. This is one of the drawbacks of the Hereford cattle. They had that white face with no pigment around their eyes. And oh my gosh, cancer eyes are a very common thing among Hereford cows. The cancer eye is bad. When they get that, you're gonna lose a cow. But there again, if you get 'em rather early you can go ahead and send 'em to the butcher cuz that meat's perfectly good to eat. I guess they mostly use it for pet food anyway. They're all good to eat if they don't have a bad disease or something like that, or crippled. But what they usually do, you send anything to market that has a bad leg or is crippled, or even if they're all healed up, they usually send those for pet food. [COW & CALF #18, MASON, p. 80]

Now there's a pose. I thought his head was down grazing but his head's up, idn't it? Isn't this his head and neck? No. This is his neck. He's grazing. I don't know. So this has to be his head down here. But this dudn't look right. I don't know what this is. [BULL #7, STREETER, p. 135]

- -

I look at these photographs and I think about what part cattle play in my life. I'm no rancher. I own no land. Just a couple houses—one in the city, one in a little town in the Hill Country. But I drive by cattle all the time as I go from city to country and back. They've become landmarks and pausing points for me. Sometimes they stand solidly—hefty statues in a rocky expanse. Sometimes you can barely see 'em, black and curled among the dry brush, resting in the shadows at midday. During the thick of August, there'll be dozens of cows crowded together under the shade of one solitary oak tree.

Doesn't matter I'm driving by at fifty, sixty, or seventy miles an hour. I see them. I look for them. In my heart, I'm with them. Walking the land. Or riding it on the horse I don't own. Goin' down to the creek, watchin' out for prickly pear. Turkey

scramblin' in the brush, deer takin' off through the trees, dove flyin' everywhere. The smell of agarita in the air. There's a wonder to it all.

That expanse of earth—without cars, asphalt, or neighbors ten feet away—is something I feel inside myself. There's this constant yearning to be in a place where there are no visible boundaries. And that's what's out there. That, to me, is Texas.

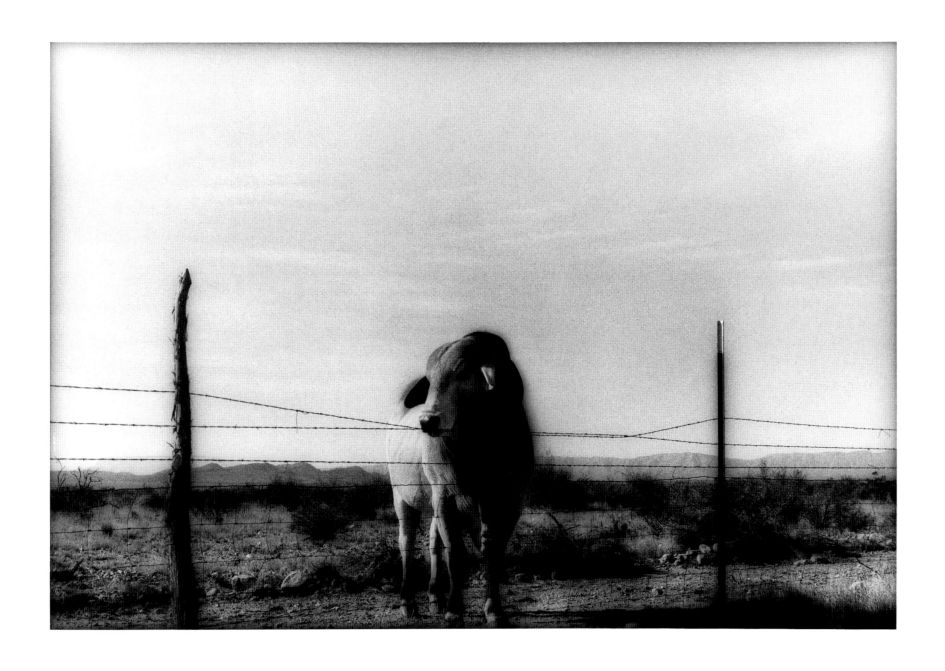

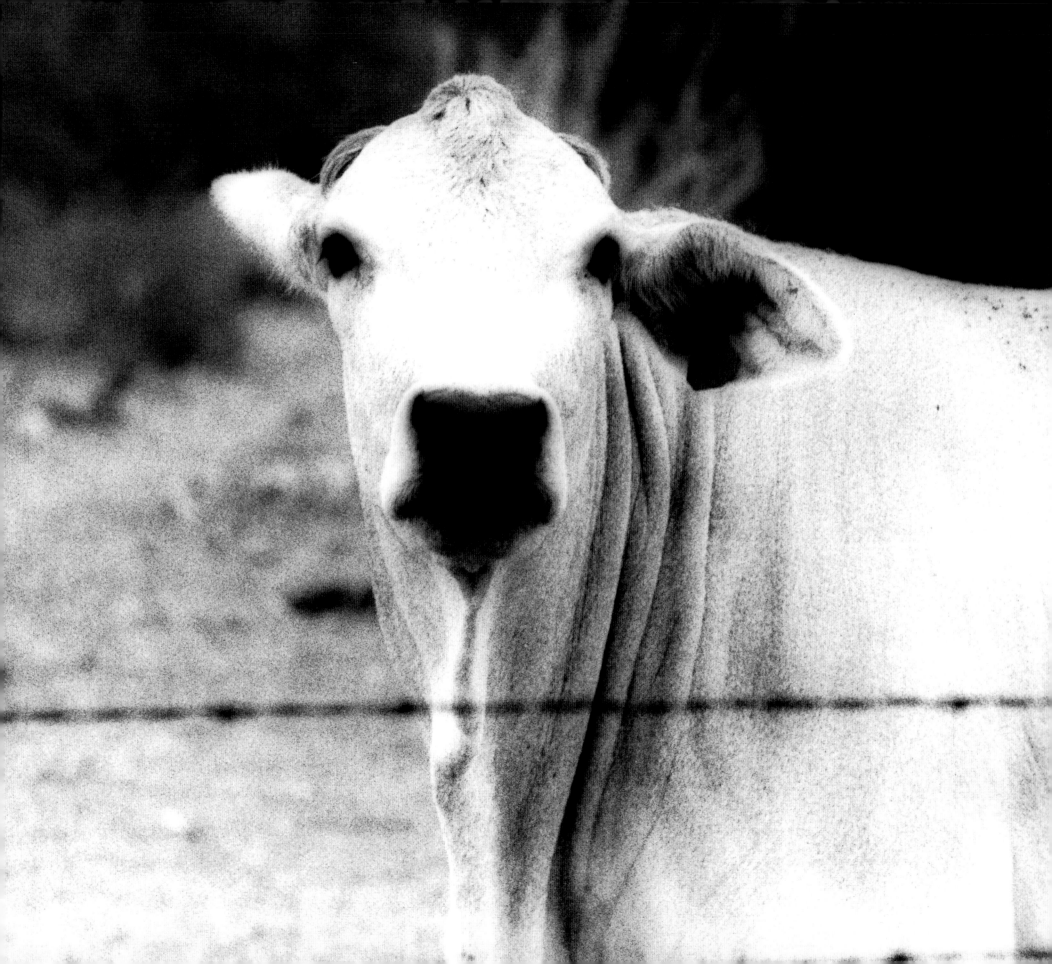

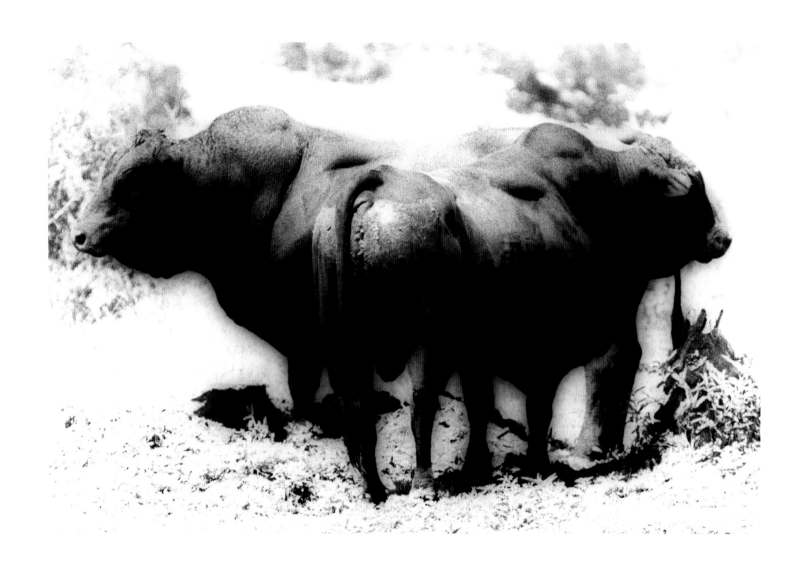

What's funny is I was raised around cattle and I've never noticed—partly because I try to stay away from the head and the rear—if I'm working with the head we've usually got it clamped down and you're

notchin' ears, you're doing something to them—you don't stop and look at the animal. So part of the reason I enjoy his photos is because you actually look at the animals that you've ignored for so long.

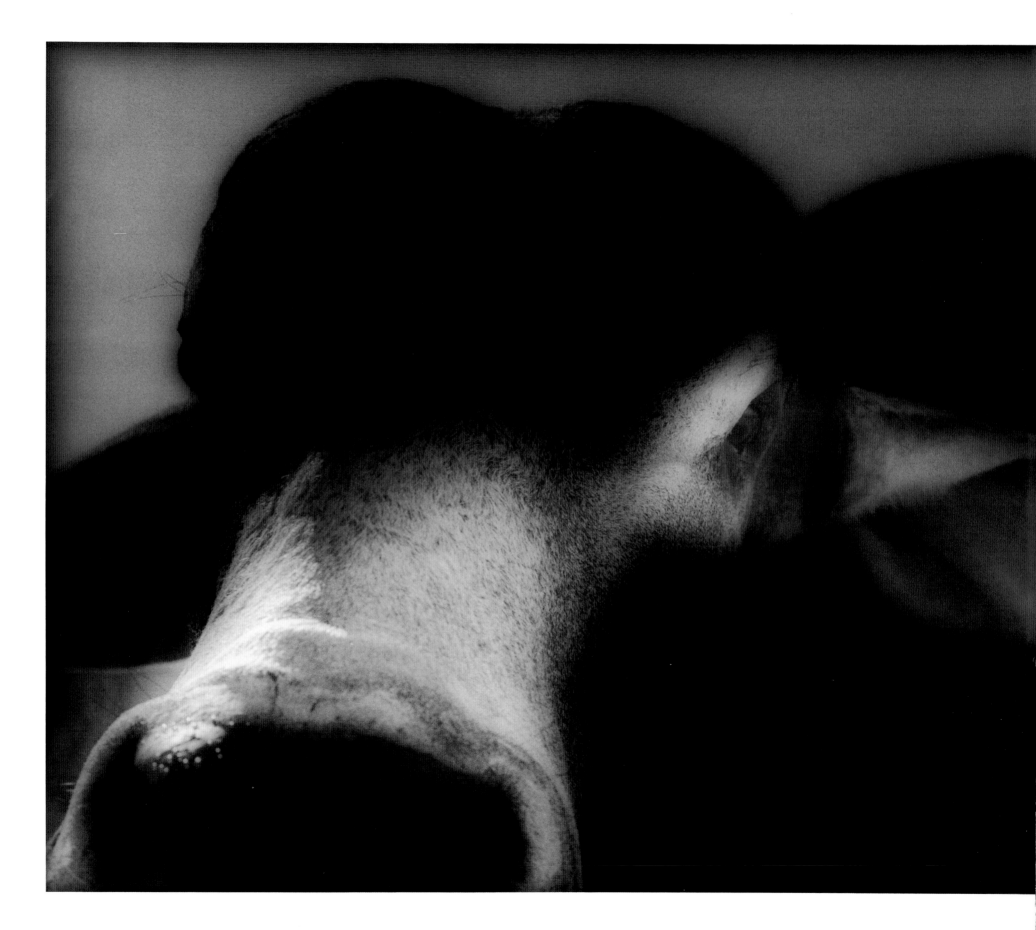

LIST OF PLATES

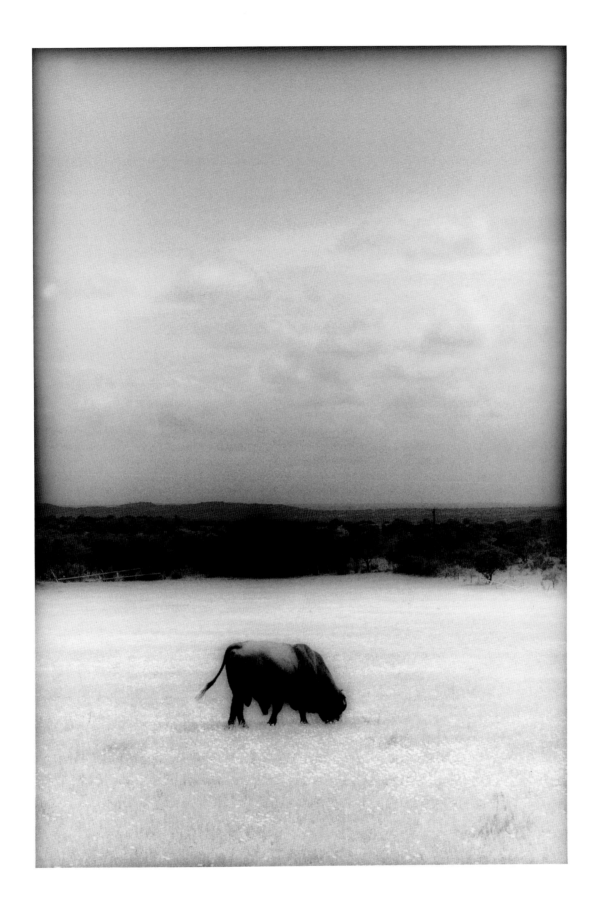

DESIGN
Henk van Assen, New York
PRINTING
Printed in China by Everbest Printing through
Four Colour Imports, Ltd., Louisville, Kentucky.
PAPER
Mitsubishi Matte Art Paper, 157gsm.
TYPEFACES
FF Scala, FF Scala Sans, FF Quadraat, FF Stampgothic